IMAGES
of America

HETCH HETCHY

IMAGES
of America

HETCH HETCHY

Beverly Hennessey

ARCADIA
PUBLISHING

Published by Arcadia Publishing
Charleston, South Carolina

Printed in the United States of America

Library of Congress Control Number: 2011944038

For all general information, please contact Arcadia Publishing:
Telephone 843-853-2070
Fax 843-853-0044
E-mail sales@arcadiapublishing.com
For customer service and orders:
Toll-Free 1-888-313-2665

Visit us on the Internet at www.arcadiapublishing.com

To my daughters, Samantha and Meredith, who are both "right as rain"; to my husband, Michael, whose passion for San Francisco history has inspired and entertained me for decades; and to the memory of Michael Maurice O'Shaughnessy and the thousands of Hetch Hetchy workers, whose laborious commitment created one of the finest water and power systems in the world.

CONTENTS

ACKNOWLEDGMENTS

I want to thank the San Francisco Public Utilities Commission (SFPUC) for supporting this endeavor and allowing me to include photographs from its amazing archives. All photographs appear courtesy of the SFPUC, unless otherwise noted. My deepest respect goes to the SFPUC photographers who have preserved this astounding Hetch Hetchy history for more than 100 years. When O'Shaughnessy Dam was constructed, dangerous and impassable terrain required physical and mental perseverance. Of special note is Horace Chaffee, the ubiquitous San Francisco staff photographer who lugged his fragile five-by-seven plate camera and other equipment from one construction site to another, creating an extraordinary visual record of the early Hetch Hetchy Project. Without his contribution, we could not fully grasp the magnitude of this undertaking. Other photographers of the project's past also are showcased in this book, including George Fanning, Marshall Moxom, Ken Snodgrass, and Lewis F. Hile.

I owe a world of gratitude to the extremely talented SFPUC photographers Katherine Du Tiel, Robin Scheswohl, and Carmen Magana for their beautiful photography and assistance in obtaining professional scans and details of the photographs from the archives. I greatly appreciate the research from Loren Chui and Jaime Henderson, both interns at the SFPUC. I extend kudos to the entire SFPUC photography division, which has preserved the photography collection and digitized images for use in many mediums. Chief photographer Katherine Du Tiel and others continue this great tradition, documenting 81 projects in the current $4.6-billion capital campaign for the Hetch Hetchy system through digital photography, film, and video. Their stunning photographs are a fitting way to end this book. More of their work can be viewed at sfwater.org or on the San Francisco Public Library's website, sfpl.org.

I must acknowledge the authors who have documented the Hetch Hetchy Project, most notably the late Ted Wurm. Wurm's nine years of extensive research and interviews, combined with his wonderful storytelling, resulted in the comprehensive and colorful publication *Hetch Hetchy and Its Dam Railroad*. Wurm's firsthand knowledge of the local community in Groveland and his affinity for the Hetch Hetchy Railroad make his history the most fascinating and detailed recollection. I also want to acknowledge Warren D. Hansen, author of *San Francisco Water and Power Department*, whose early account and chronology of 1985 has served as important documentation that other city staff writers have conscientiously updated over the years.

I thank former Arcadia Publishing acquisitions editor John Poultney for his early support and gentle perseverance; publisher Tiffany Frary for her expertise and unwavering patience; and production editor Tim Sumerel for his discernful eye. I would be remiss if I did not thank my dear friend and sister Susan Lohwasser and her partner, Tre Ford, whose advice has been invaluable. And last, but not least, thank you to the "Rock" Mike Hennessey for his steadfast and calm demeanor during my computer meltdowns.

INTRODUCTION

Water is H₂O, hydrogen two parts, oxygen one, but there is also a third thing that makes it water and nobody knows what that is.

—D.H. Lawrence
"The Third Thing," in *Pansies*, 1929

Whiskey's for drinking and water's for fighting over.

—attributed to Mark Twain

All the water that will ever be is, right now.

—*National Geographic*, October 1993

The history of the Hetch Hetchy Project, owned and operated by the City and County of San Francisco, is a complicated story full of political maneuvering, corruption, lobbying, environmental debate, backstabbing by competing water companies and interests, and challenging construction. Michael O'Shaughnessy, chief engineer for the project for two decades, opined in his final written account of the project in 1934, shortly before his death, "I never handled any proposition where the engineering problems were so simple and the political ones so complex." The Hetch Hetchy Aqueduct is an extraordinary water and power system that is comprised of 60 miles of tunnels (some excavated through solid granite), 280 miles of pipelines, four major dams, four powerhouses, two treatment plants, and 11 reservoirs. It has been deemed an engineering marvel.

During the project, the best hydraulic engineers came from all over to work on the great Hetch Hetchy Project with Michael Maurice O'Shaughnessy, known as "the Chief." Today, the Hetch Hetchy system continues to deliver on average 260 million gallons of potable water every day, gravity-fed from the Tuolumne River watershed in the Sierra Nevada, approximately 160 miles across California. The use of a gravity-fed system is significant in California, since pumping to transport water around the state is a major drain on electricity.

Mayor James Rolph and Mayor James D. Phelan, who backed O'Shaughnessy during this difficult endeavor, provided support that was instrumental to the success of the project. The leaders and citizens of early San Francisco ultimately chose the Tuolumne River watershed, not only for its sustainability, but also for its pristine water, emanating from the glaciers and runoff from Mount Lyell headwaters at 13,120 feet above sea level in Yosemite National Park. After years of national debate, public hearings, media coverage, and an act of Congress passed in 1913, the Hetch Hetchy Project was finally underway. The opposition, led by Sierra Club president John Muir, galvanized one of the nation's earliest conservation fights against the passage of an act of Congress, known as the Raker Act of 1913. This bill, signed by Pres. Woodrow Wilson, gave San Francisco permission to utilize rights-of-way in Yosemite National Park to build O'Shaughnessy Dam, which created the Hetch Hetchy Reservoir.

For two decades after the Raker Act passed into law, San Francisco workers toiled from the Sierra Nevada to the San Francisco Bay Area, from snowfall to outfall, to build the Hetch Hetchy Aqueduct. By the end of 1934, San Francisco voters had passed seven bond measures for $102 million to fund the construction of Hetch Hetchy.

There was also a high price paid in loss of human life. Over the 20-year period, 89 workers were killed, including the 12 lives lost in one single explosion. The San Francisco Bay Area has a semiarid geography and Mediterranean climate, with an average rainfall of 23 inches. Californians rely on runoff from over 24 Sierra Nevada watersheds for more than 60 percent of their overall potable water. (More than half of this water from the Sierra Nevada is used for agriculture, while five percent of it is consumed by urban use.) Most Americans take it for granted that they can turn on their faucets everyday and out pours the water. With global population on the rise, the demand for clean water is increasing. It is shocking that today, more than 20 percent of the world's population either does not have access to clean, potable water or water that is not prohibitively expensive. Each year, more than 2.2 million people die, many of them children, from water-related diseases. As the author of *Cadillac Desert,* the late Marc Reisner, reminded us: "rain is always a good thing."

The future challenges of water delivery for utility managers are daunting. Ironically, on a planet where the surface is 71 percent water, only one percent of the overall water is suitable for human consumption. Issues of drought, global warming, population growth, and pollution complicate competing water needs for human consumption, agriculture, environment, industry, and recreation. Now, as America grows older, capital campaigns to repair and upgrade aging water infrastructure are on the horizon. Improved engineering designs have evolved from lessons learned during past experiences, including earthquakes, erosion, flooding, and droughts. These water projects will offer opportunities to educate more people about their water and instill new ways for conserving and protecting water resources and the environment.

In the late 1800s and early 1900s, San Francisco leaders conducted studies and reviews of 14 possible water sources for the Bay Area, and always the Tuolumne River watershed ranked first for the highest quality and quantity of water. The Freeman Report, the US Geological Survey (USGS), and the Board of Army Engineers all had concurred that the Tuolumne River basin would provide the Bay Area with a highly protected source of water, with most of the 459-square-mile watershed above 6,000 feet in elevation and its headwaters at Mount Lyell. This northwestern portion of Yosemite National Park is visited by an increased number of visitors each year. Some of the most popular park activities include hiking, backpacking, fishing, and enjoying the incredible vistas and waterfalls.

This Hetch Hetchy history, told through amazing historical photographs, is only a sampling of the richly dynamic story of the construction of the Hetch Hetchy Project, owned and operated by San Francisco. Today, it is a regional system that delivers water to 2.4 million people in Tuolumne, Alameda, Santa Clara, San Mateo, and San Francisco Counties and is one of the city's greatest revenue generating assets. The Hetch Hetchy system provides the foundation for the healthy populace and robust economy that make the San Francisco Bay Area and the Silicon Valley such extraordinary places to live and visit.

One

WATER IN EARLY SAN FRANCISCO

The now-thriving metropolis of San Francisco, a peninsula surrounded on three sides by saltwater, began as a sleepy little pueblo after first being settled by Spanish explorers. In 1776, Padre Francisco Palou and Juan Bautista De Anza founded Presidio Pueblo and Mission Bay San Francisco, where the population stabilized at a few hundred people for many years. Visitors were not encouraged. The local water supplies, from Islais Creek, Lobos Creek, Mountain Lake, and a few springs and wells in the area, were adequate for a time. Today, most of these creeks and springs in San Francisco have been filled and built over. Lobos Creek in the Presidio is an exception and continues to produce approximately two million gallons of potable water each day.

Life in the Spanish pueblo was quiet and slow paced. When Spanish rule ended in 1821, Mexico opened the mission lands to settlers under less-restrictive policies. Trade was encouraged under Mexican governor Figueroa, who established a trading post at Yerba Buena Cove. When the Gold Rush exploded in 1849, San Francisco's population soared to more than 100,000. The surface water, springs, and streams in San Francisco were no longer adequate for the burgeoning population. Water peddlers started to import water from Sausalito to supplement water supplies. The quest for an adequate water supply was underway for San Francisco, today one of the most popular tourist destinations in the world. Water companies became fiercely competitive, with one company clearly emerging as the leader: Spring Valley Water Company. San Francisco officials attempted to purchase Spring Valley Water Company in 1873, 1875, and 1877, to no avail.

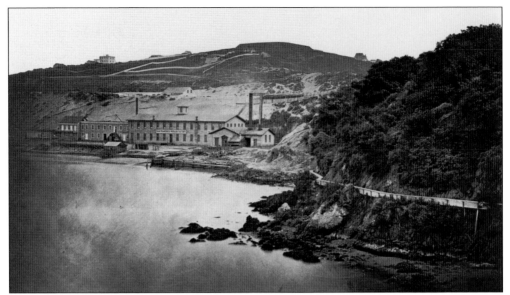

San Francisco Water Works began delivering potable water from Lobos Creek to San Francisco residents. Spring Valley Water Company absorbed the San Francisco Water Works in 1865. A portion of the wooden flume, seen here, conveyed water from Lobos Creek, rounded Black Point (Fort Mason today), and continued to the Lombard and Francisco Reservoirs in San Francisco. (Courtesy of the San Francisco Public Library, around 1865.)

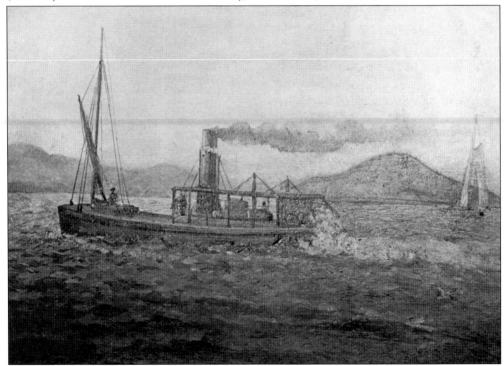

Water was imported on ships from Sausalito and sold by the barrel. This painting shows a barge called *Little Water Witch* of the Pacific Coast Steamship Company's fleet, which carried potable water to San Francisco in the 1870s. (Courtesy of the Bancroft Library, University of California, Berkeley.)

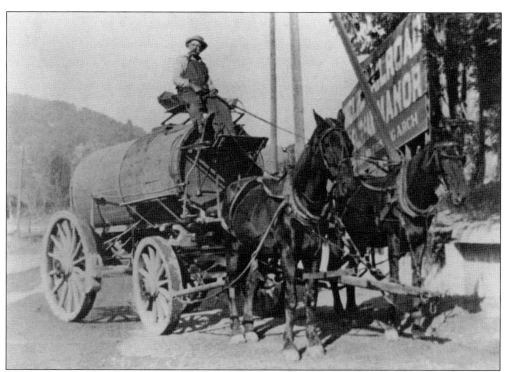

Water sellers delivered potable water by horse-drawn carts in San Francisco in 1855. Many vendors had established water routes with regular customers. The following year, Spring Valley Water Company developed Islais Creek in San Francisco as its first water supply, and it purchased the Lobos Creek supply as well. During 70 years of operation, Spring Valley Water Company acquired thousands of acres of protected watershed lands in the east and south bays. Today, there are approximately 57,000 acres in these two protected regional watersheds owned by San Francisco that yield 15 percent of the overall water delivered by the Hetch Hetchy system. These undeveloped lands also provide vital habitat for a variety of flora and fauna, many of which are endangered.

This c. 1890 photograph shows the picturesque Stone Dam, constructed below the Pilarcitos Dam in 1872 with a capacity of 45 million gallons of water. Both dams were built by the Spring Valley Water Company to maximize benefits from the productive lower watershed in the Crystal Springs Reservoir south of San Francisco. Stone Dam is still operational and is an example of rubble masonry, built of granite blocks quarried below the dam site.

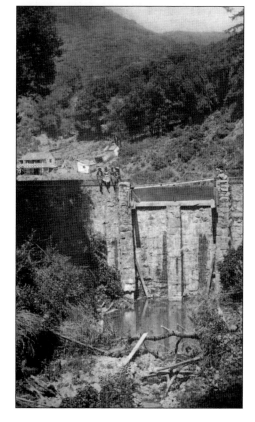

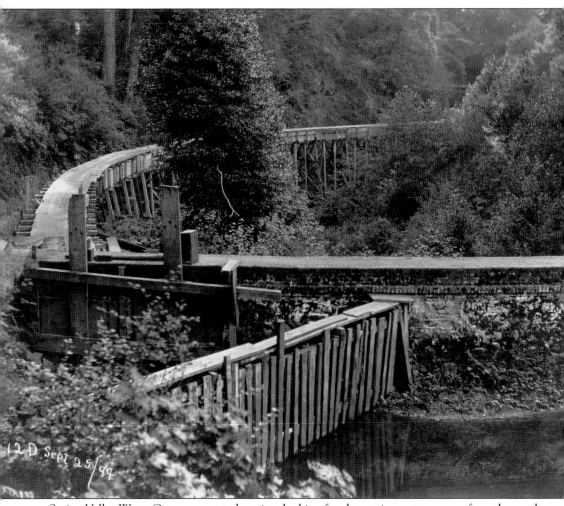

Spring Valley Water Company wasted no time looking for alternative water sources from the south on the San Francisco Peninsula. Built under the supervision of engineer Alexei W. Von Schmidt and pictured here around 1899, one of the first facilities was a dam at Pilarcitos Creek (meaning "little water basin") that would transfer water to Laguna Honda Reservoir in San Francisco via wooden flume and pipeline. Von Schmidt had previously developed water from Lobos Creek for Bensley Water Company in 1860 before leaving due to a dispute over compensation for a meter he had invented. After working for Spring Valley Water Company, Von Schmidt went on to become a key player in the further development of watersheds in the Sierra Nevada.

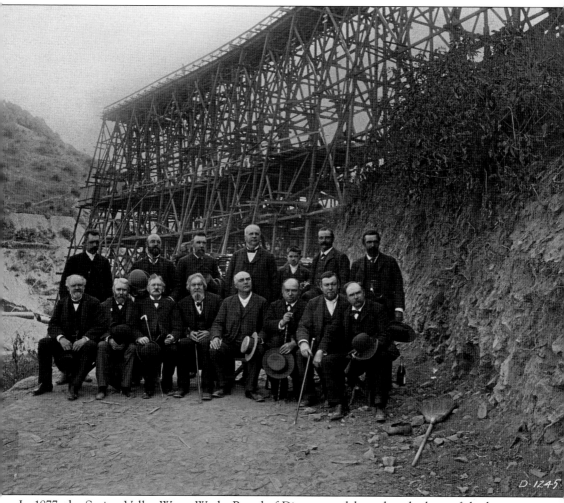

In 1877, the Spring Valley Water Works Board of Directors celebrated at the base of the lower Crystal Springs Dam being constructed over San Mateo Creek south of San Francisco. (Note the champagne bottle on the right side of the back row.) Hermann Schussler, a brilliant engineer from Switzerland, pictured second from the left in the back row, managed the construction of the vital waterworks on the peninsula and East Bay. Schussler stayed with Spring Valley Water Company until 1909 and assisted with restoration of the system after the Great Earthquake of 1906.

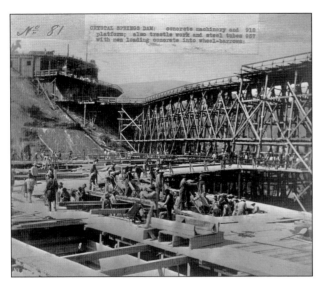

At the base of the Crystal Springs Dam, Spring Valley Water Company constructed an outlet tunnel with a large 44-inch regulating gate for water from the reservoir. This dam, pictured here around 1887, was constructed of large interlocking blocks of concrete that were poured and formed at the work site under the supervision of Hermann Schussler. It has withstood both the 1906 and the 1989 earthquakes without damage, in spite of its proximity to the San Andreas Fault line. In 1976, it was designated a California Historic Civil Engineering Landmark.

This c. 1887 photograph shows Spring Valley Water Company workers operating concrete machinery on the platform and pouring concrete from wheelbarrows at lower Crystal Springs Dam, completed in 1888. The dam has a capacity to impound 22.5 billion gallons of water in the Crystal Springs Reservoir.

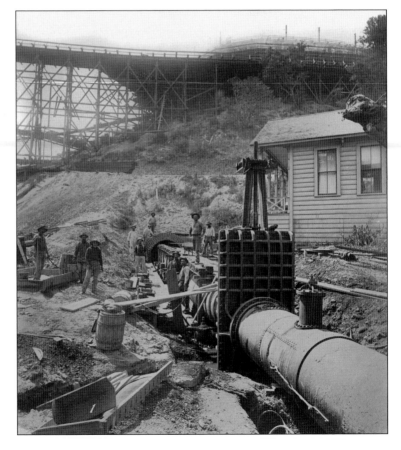

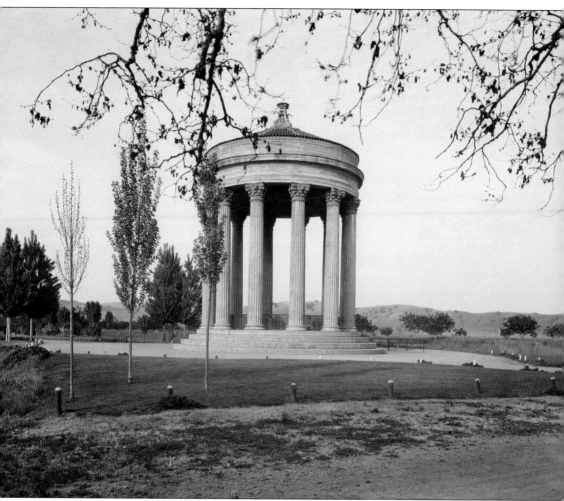

Sunol Water Temple, designed by famed San Francisco architect Willis Polk, was built in 1910 by Spring Valley Water Company as a tribute to the confluence of three water sources: Pleasanton Wells, Alameda Creek, and Arroyo de la Laguna. That same year, San Francisco voters overwhelmingly approved a bond measure for $45 million to initiate the Hetch Hetchy Project. (Photograph by George Fanning, June 2, 1921.)

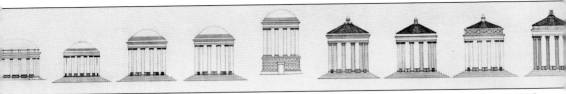

After the Sunol Water Temple was damaged in the 1989 Loma Prieta Earthquake, the SFPUC renovated the structure and restored its ceiling murals and finial in partnership with the Sunol community and the Oakland Museum. The Sunol Water Temple was designated a California Historical Engineering Landmark in 1976 by the American Society of Civil Engineers and remains open to the public today. Pictured here are various designs of the Sunol Water Temple by architect Willis Polk. The designs were inspired by the Temple of Vesta built in the first century BC at Tivoli (near Rome), Italy, where waters from the Apennines cascade down the Sabine Hills.

Two

THE SEARCH FOR SUSTAINABLE WATER

The search for a reliable and adequate water source for San Francisco residents began in earnest in the late 1800s. The city had been destroyed by fire six times between 1850 and 1852, due to the lack of water to extinguish fires. Numerous engineering and governmental studies were underway by the turn of the century, as San Francisco's population climbed to more than 350,000 following the Gold Rush. Enthusiasm was building amongst engineers and politicians who were looking to the Tuolumne River basin as the best selection. In 1900, Mayor James D. Phelan directed city engineer Carl Grunsky to study 14 different water sources, including Lake Tahoe, Spring Valley Water Company, Clear Lake and Cache Creek, Bay Shore Gravels, Bay Cities Water Company, and the Eel, San Joaquin, Yuba, Stanislaus, Feather, Mokelumne, American, Tuolumne, and Sacramento Rivers.

Grunsky, also a geologist, came to the same conclusion as his successor Marsden Manson. They concurred that the Tuolumne River was the most sustainable water source based on the high quality and quantity of water; that it was the best reservoir site, with a very deep granite basin free of pollutants; that there were no conflicting water claims like those that existed in other watersheds; and that it had excellent hydropower potential. The US Geological Survey (USGS) also released a report in 1900 finding the Tuolumne River as the best source of sustainable water for San Francisco.

Unfortunately, some political leaders at the time, including San Francisco mayor Eugene Schmidt, later indicted for corruption, prevented the city from moving forward with the viable water plan until 1907. The Great Earthquake of 1906 ended the indecision and political wrangling after the city burned for three days and more than 3,000 lives were lost. San Francisco, in the aftermath of the 1906 earthquake and fires, saw widespread support for the Raker Act, including influential help from Pennsylvania governor Gifford Pinchot and newspaper magnate William Randolph Hearst. Hearst dispatched his reporters to Washington, DC, where, on the morning of the congressional vote, they delivered a special edition newspaper in support of the Hetch Hetchy Project to every voting member.

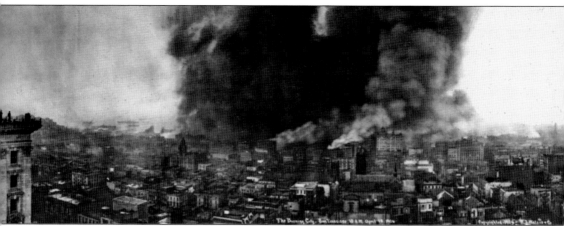

The Great Earthquake of 1906 and resulting fires served as the impetus for the approval and construction of the Hetch Hetchy Project, but not before political corruption led to convictions

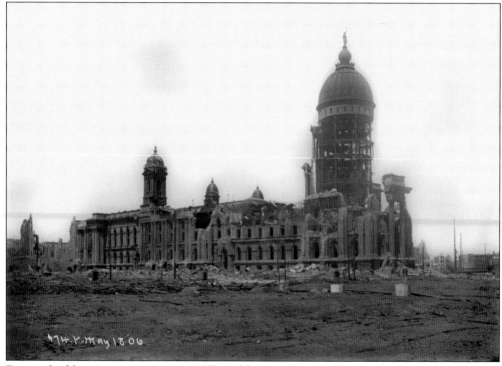

Due to shoddy construction practices allowed by corrupt city officials, the former city hall was destroyed in the Great Earthquake of 1906, launching a series of investigations. Political boss Abe Ruef distributed boodle to the board of supervisors in an attempt to get the approval of a competing interest to use the Mokelumne River and to derail the Hetch Hetchy Project. Ruef was prosecuted and spent five years in San Quentin Prison. Mayor Eugene Schmidt also was prosecuted and found guilty, although his conviction was later overturned. Other members of the San Francisco Board of Supervisors resigned after the trials. It was largely due to the efforts of Mayor James D. Phelan, who spearheaded a civic reform movement, that the Hetch Hetchy Project moved forward—even though he was no longer mayor at the time.

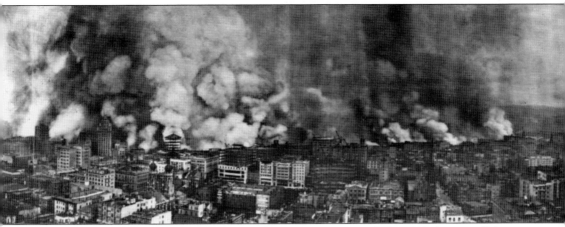

and resignations. Stability was finally reinstated in San Francisco with the 1912 election of Mayor James Rolph, who served for 18 years before being elected governor of California in 1930.

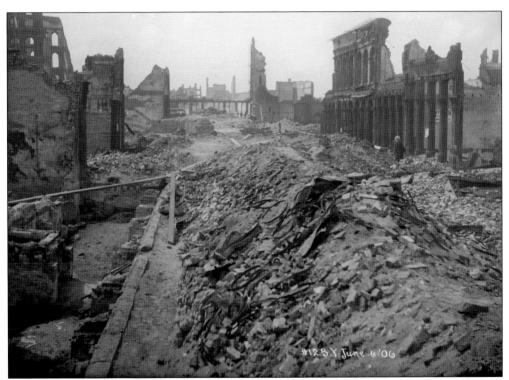

The extensive devastation of Battery Street in the downtown area of San Francisco is apparent on June 6, 1906, two months after the earthquake. Immediately following the great earthquake, Hermann Schussler of Spring Valley Water Company left for the pipe yard in San Francisco, where he met with his staff. They set forth to repair more than 300 major pipe breaks. However, Schussler's assessment of the disaster considered the most serious water problem to be "shutting off the thousands of broken service pipes and house supply pipes that were torn off by the burning and falling buildings during the conflagration."

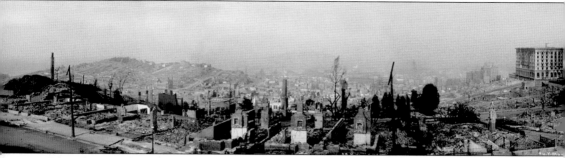

This photograph of the earthquake destruction in San Francisco was taken from a city reservoir. "Not in history has a modern imperial city been so completely destroyed. San Francisco is gone.

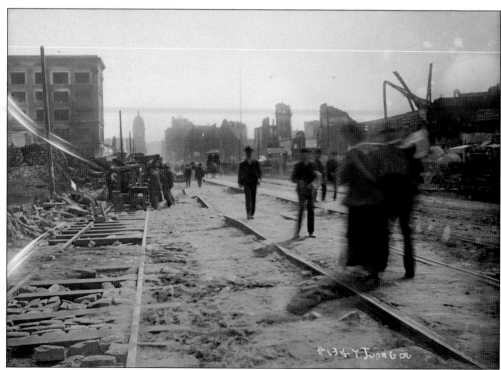

Citizens of San Francisco walk along what had been Market Street, considered a main thoroughfare, on June 6, 1906. There was an estimated $400 million (in 1906 dollars) of property damage.

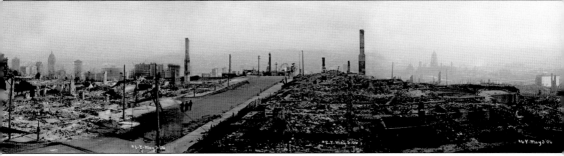

Nothing remains of it but memories and a fringe of dwelling-houses on its outskirts," wrote Jack London just days after his observations of the 1906 earthquake.

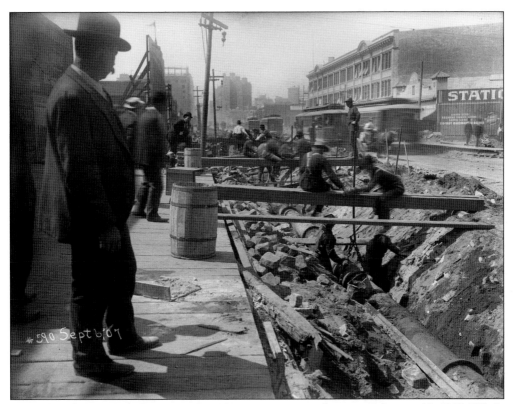

Howard and Twentieth Streets in San Francisco are seen here on February 27, 1907. While reconstruction continued, city officials persevered in their endeavor to obtain permission to build the Hetch Hetchy system. Because development of the city's water rights required the approval of the secretary of the interior, such applications were subject to political pressure and the political climate of the federal administration. Secretary of the Interior Ethan Hitchcock had denied San Francisco's first application in 1903. In 1908, the city again applied to Secretary of the Interior James R. Garfield only to be granted the Garfield Permit, a precursor to the Raker Act. City leaders were concerned that this permit could be revoked at any time under a different secretary.

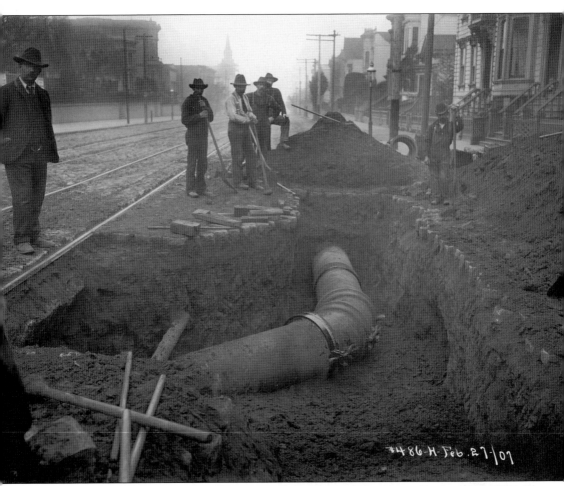

Main and Spear Streets in San Francisco still faced reconstruction on September 6, 1907. The earthquake damage and the investigations and trials in San Francisco had delayed progress on approval for the Hetch Hetchy Project. However, the momentum did not falter, and the campaign was still in good hands. On April 22, 1908, engineer Marsden Manson filed duplicates of the early Hetch Hetchy maps with Secretary of the Interior James R. Garfield to ensure all papers were in order with the federal government.

Mayor James D. Phelan, the son of an Irish immigrant who became wealthy selling dry goods during the Gold Rush, quietly secured some of the early water rights in 1901 for the city, so as not to draw attention to the acquisition from competitors. This began the lengthy, 10-year period of negotiations and conflict with the federal government, John Muir and conservationists, the Modesto and Turlock Irrigation Districts, Spring Valley Water Company, and other competing interests over the passage of the Raker Act. Phelan went on to serve as US senator from 1915 to 1921.

New concerns rose among Modesto and Turlock farmers who shared senior water rights on the Tuolumne River. In 1910, under new secretary of the interior Richard Ballinger, San Francisco was issued an order to show justification why the Garfield Permit, allowing rights-of-way in Hetch Hetchy Valley, should not be revoked. The city hired John Freeman, a renowned hydraulic engineer from Providence, Rhode Island, who published a detailed preliminary plan called the Freeman Report. This 400-page document was reviewed by the Board of Army Engineers and paved the way for approval and construction of the Hetch Hetchy Project. The Freeman Report showed that the Tuolumne River source water was the lowest-cost alternative for the city. It also proved that the Tuolumne River plan would be the least complicated in the acquisition of the necessary water rights.

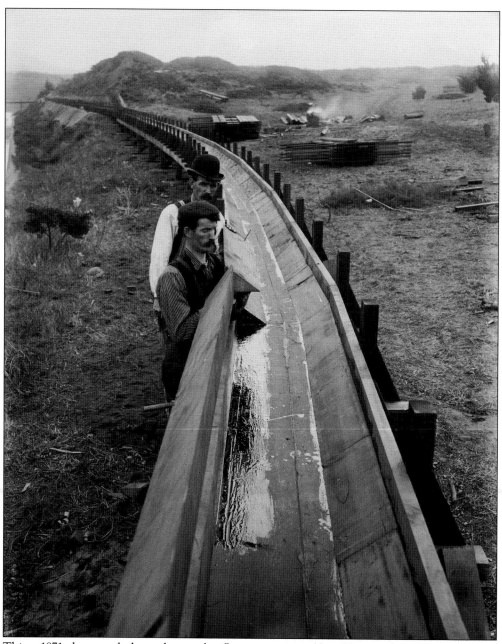

This c. 1871 photograph shows the wooden flume, maintained by adding angled sides to aid in the transportation of water, before pipelines were installed south of San Francisco. Wooden flumes were elevated boxes used in early water transport, usually constructed of durable redwood and made to follow the contour of the land.

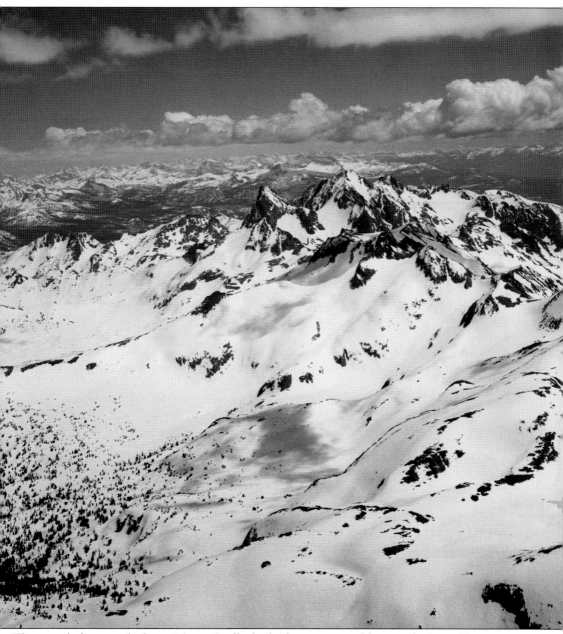

This aerial photograph shows Mount Lyell, the highest point and largest glacier in Yosemite National Park, at 13,120 feet above sea level. It is named after renowned geologist Charles Lyell and is the headwaters for the 459-square-mile Tuolumne River watershed. Mount Lyell is part of the Cathedral Range, located south of Tuolumne Meadows in Yosemite National Park. Glaciers moving slowly over solid granite rock formed the range and sculpted uniquely jagged spires, which resembled cathedrals. Approximately 287 miles of trails meander throughout the Hetch Hetchy watershed, including a portion of the Pacific Crest Trail. Yosemite National Park has two federally designated wild and scenic rivers, the Tuolumne and the Merced, that are protected from development under the Wild and Scenic Rivers Act, approved by Congress in 1968. (Photograph by Marshall Moxom, June 15, 1967.)

Mayor "Sunny" Jim Rolph, nicknamed for his positive disposition, was the longest-serving mayor of San Francisco. His term lasted 18 years, during which time Michael O'Shaughnessy answered only to him. Mayor Rolph remained very supportive of O'Shaughnessy and ran interference in the perpetual politics of the Hetch Hetchy Project. During the Great Depression, Mayor Rolph became the 27th governor of California, two years before the aqueduct was completed. Once his ally had moved on to a new office, O'Shaughnessy was heavily criticized for project delays that were out of his control.

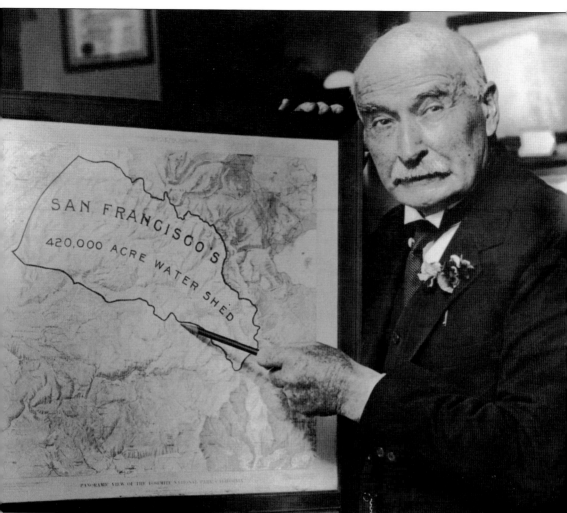

Michael O'Shaughnessy held an engineering degree from the Royal University in Dublin, Ireland. His experience included the construction of three aqueducts and 30 miles of tunnels to irrigate sugar plantations in Hawaii from 1900 to 1906. He also worked as chief engineer of the Southern California Mountain Water Company from 1907 to 1912, directly for two wealthy San Franciscans, John D. and A.B. Spreckles. During this time, O'Shaughnessy oversaw the construction of the water system in San Diego, where the Spreckles family had huge property holdings. O'Shaughnessy was involved in the engineering of the Golden Gate Bridge and the municipal transportation system in San Francisco. His first employment experience with the city had not been pleasant because he felt he had not adequately been compensated. When Mayor Rolph wired him 10 months after becoming mayor and urged him to accept the job as the city engineer, O'Shaughnessy was reluctant at first to assume the position. According to O'Shaughnessy, his wife, a native San Franciscan, played a major role in convincing him to accept the job. He was described by some as irascible and tenacious, but also as a man of action who was greatly respected by the men and women who worked on the project. Many workers, in particular the tunnelers, came from as far away as Sweden to work with "the Chief," O'Shaughnessy's nickname for 20 years.

It became clear to city leaders, during dealings with the various secretaries of the interior, that the only guarantee for a grant of the necessary rights-of-way to build the Hetch Hetchy Project would require an act of Congress. Congressman John E. Raker of Manteca, pictured here, authored and introduced the necessary bill in 1913. Hearings were held to ensure the protection of the districts' water rights. Congressman William Kent, who had purchased more than 400 acres of redwoods in Marin County to save them from destruction, supported and shepherded the bill through Congress.

President Wilson signed the Raker Act in 1913, ending years of debate. The act imposed many conditions and requirements on San Francisco in exchange for permission to utilize the rights-of-way in Yosemite National Park to build the Hetch Hetchy Project. These conditions included: recognition of the first water rights of Modesto and Turlock Irrigation Districts, maintenance and construction of roads and trails, commencement of construction on the dam immediately, ongoing enforcement of sanitary measures within the watershed, and development of hydropower for municipal use.

THE WHITE HOUSE
WASHINGTON

December 19, 1913.

I have signed this bill because it seemed to serve the pressing public needs of the region concerned better than they could be served in any other way and yet did not impair the usefulness or materially detract from the beauty of the public domain. The bill was opposed by so many public spirited men, thoughtful of the interests of the people and of fine conscience in every matter of public concern, that I have naturally sought to scrutinize it very closely. I take the liberty of thinking that their fears and objections were not well founded. I believe the bill to be, on the whole, in the public interest, and I am the less uncertain in that judgment because I find it concurred in by men whose best energies have been devoted to conservation and the safe-guarding of the people's interests, and many of whom have, besides, had a long experience in the public service which has made them circumspect in forming an opinion upon such matters.

Woodrow Wilson

In 1912, famous naturalist and founder of the Sierra Club John Muir was the main protagonist in the Raker Act debate. He and many Sierra Club members wanted to preserve Hetch Hetchy Valley in its natural state. For five years, Muir vigorously led the fight against building the dam. He did not attend the congressional hearings for the Raker Act in 1913. In 1912, Muir published his influential book, *The Yosemite*, with the fiery quotation, "Dam Hetch Hetchy. As well dam for water-tanks the people's cathedrals and churches, for no holier temple has ever been consecrated by the heart of man." There was widespread national debate. Many people confused Hetch Hetchy Valley with the larger Yosemite Valley, located 17 miles to the south along the Merced River. Other opposition stemmed from the Spring Valley Water Company and the irrigation districts. The districts had legitimate concerns that their senior water rights remain guaranteed. They eventually came to an agreement with San Francisco to protect their interests.

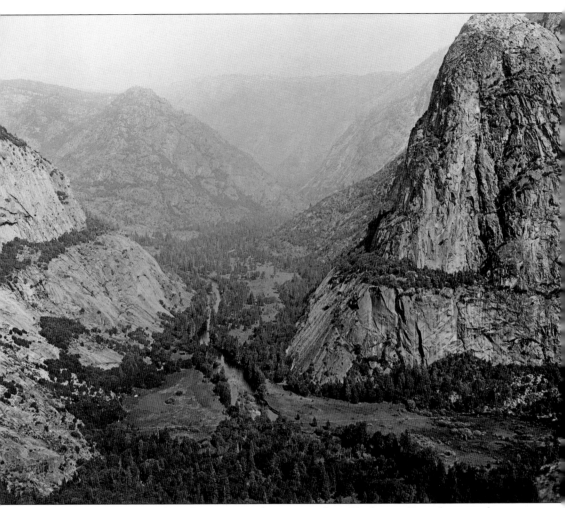

The Hetch Hetchy Valley floor, impounding waters from Tuolumne River basin with its steep and shear granite walls, was to be the main storage reservoir providing approximately 85 percent of the water delivered by the system from the runoff and snowmelt. The name *Hetch Hetchy* evolved from the Sierra Miwok word *hatchatchie*, which referred to a plant or grass with edible seeds that grew in the area.

Three

CONSTRUCTION OF O'SHAUGHNESSY DAM

The first phase of the Hetch Hetchy Project was to create the infrastructure necessary to build O'Shaughnessy Dam. This incredible portion of the history includes the construction of the Hetch Hetchy Railroad (HHRR), a 68-mile-long, standard-gauge railroad to navigate through steep and almost impassable terrain; construction of Early Intake Powerhouse to supply electricity to permit night construction, which hastened the project's completion; and construction of Canyon Ranch and Hog Ranch sawmills, which supplied the timber for the project. Work began quickly after the Raker Act was ratified, even though San Francisco was still under reconstruction from the 1906 earthquake and World War I was depleting resources. The war also was driving up the cost of steel.

During the construction in the High Sierra, the Hetch Hetchy Project headquarters were located alongside what is today the Highway 120 corridor through Groveland, which leads to the Big Oak Flat entrance to Yosemite National Park. Portions of the current Highway 120 were the original right-of-way for the HHRR. San Francisco also built infrastructure in Groveland, such as water and sewer lines, and hired local residents to show support and garner cooperation from the community. The Roaring Twenties were very much alive in Groveland, which had its share of gambling, brothels, and bootlegging. But folks felt safe in the close-knit community, where residents and workers respected each other and rarely needed the services of the sheriff in Sonora. Grovelanders embraced the "spirit of Hetch Hetchy" as it became known, and they had relatives who worked on the project. Many of them still take great pride in this local heritage.

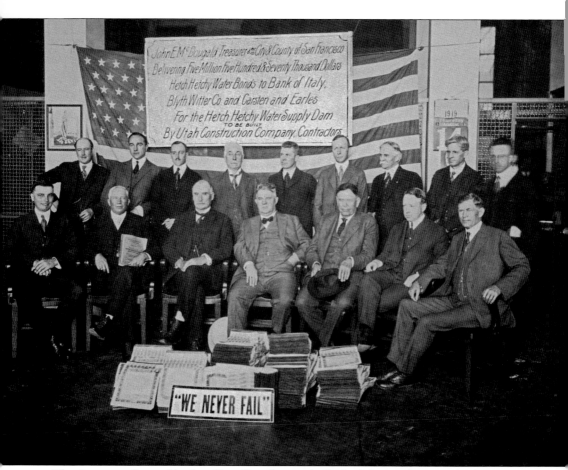

The American flag and big bundles of bonds provide the backdrop and staging for the excitement that prevailed over the delivery of bonds to the Bank of Italy on August 14, 1919. This step secured the services of Utah Construction Company to build O'Shaughnessy Dam. San Francisco supervisor Ralph McLeran is seated with his hand in his pocket, directly in the middle of the front row. Michael O'Shaughnessy is seated third from the left in the front row. Supervisor McLeran would use "cheap politics" to halt the Hetch Hetchy Project on several occasions, as O'Shaughnessy later wrote in 1932. Supervisor McLeran issued stop work orders that were overturned by judges.

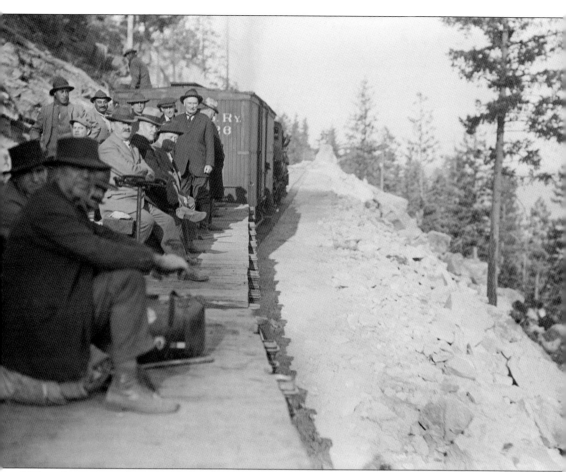

O'Shaughnessy stands in the back right with Hetch Hetchy supervisors, traveling on the flatcar on a trip to review the completion of the railroad construction. This inspection was done for the city to assume responsibility from HHRR contractor Frederick Rolandi, pictured with arms folded, wearing a light-colored suit. (Photograph by Horace Chaffee, September 19, 1917.)

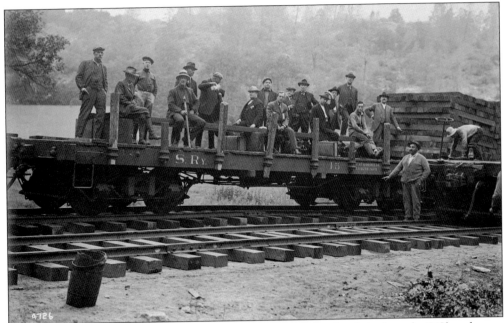

San Francisco supervisors and workers ride on a flatcar carrying railroad ties from the O'Shaughnessy Dam site. Railroad workers dropped steel rails from flatcars onto the waiting wooden ties. The HHRR ran until 1949, when the railroad was dismantled. (Photograph by Horace Chaffee, September 19, 1917.)

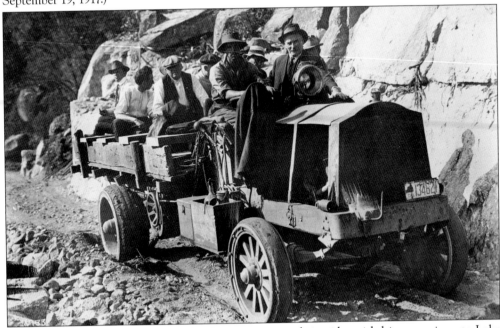

Michael O'Shaughnessy, seated in the front in a suit and tie, rides with his supervisors to Lake Eleanor on September 20, 1917. The Cherry Creek diversion dam construction was completed, and Eleanor Dam construction commenced. The construction of Eleanor Dam was necessary to divert waters for operations at the Early Intake Powerhouse, which would supply the electricity for the continuous construction of O'Shaughnessy Dam.

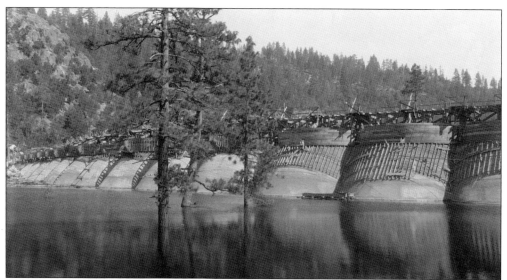

Constructed in 1918, Eleanor Dam, the first in the Hetch Hetchy Project, is a multi-arch design built on Lake Eleanor to a height of 70 feet and a length of 1,260 feet. It was constructed 10 months after the project started and holds 28,000 acre-feet of water. (An acre-foot of water is the equivalent of 325,853 gallons of water.) Today, Lake Eleanor is a favorite recreational spot, especially for local residents in Tuolumne County. It is located in Yosemite National Park. (Photograph by Horace Chaffee, August 9, 1918.)

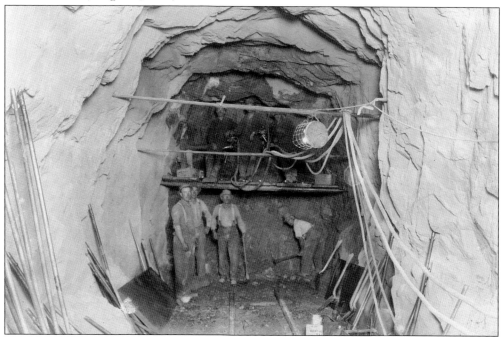

A three-mile-long system of flumes, pipes, tunnels, and concrete-lined canals delivered the combined waters from Cherry Creek and Lake Eleanor to the hillside 345 feet above Early Intake Powerhouse, where the water entered the penstocks anchored to the mountainside. It was arduous labor without the use of today's tunnel-boring machines. (Photograph by Horace Chaffee, August 12, 1918.)

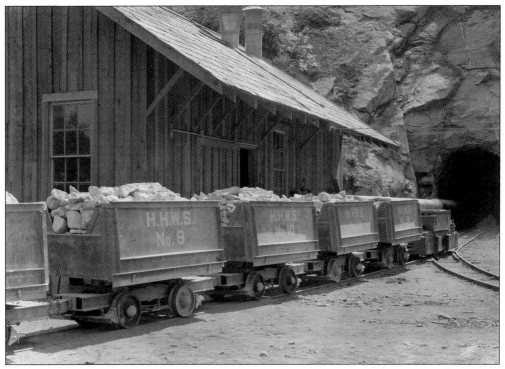

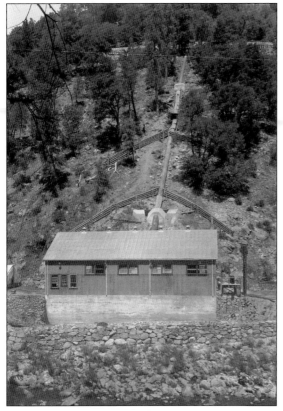

This electric muck train was the workhorse of the massive tunneling efforts during the project. This one was manufactured by General Electric and removed the materials excavated at the tunnel to Early Intake Powerhouse. In the interest of efficient use of time and finances, Chief O'Shaughnessy was said to have opted for durable but simple equipment that did not require frequent repairs. (Photograph by Horace Chaffee, May 9, 1919.)

Early Intake Powerhouse was constructed 12 miles downstream from Hetch Hetchy Reservoir on the Tuolumne River. It produced $550,000 worth of electricity for the Hetch Hetchy Project and generated an additional $750,000 in revenue from power sales. (Photograph by Horace Chaffee, September 12, 1918.)

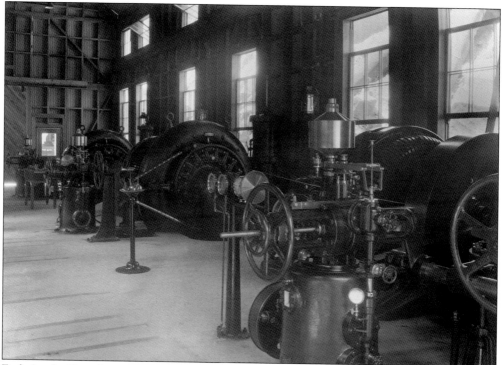

Early Intake Powerhouse remained in operation for 46 years, until 1960. The Early Intake, seen here, was equipped with three 1,500-horsepower Pelton–Francis turbines that connected directly to three generators. The Kirkwood Powerhouse, originally named Canyon Powerhouse, was constructed near Early Intake in 1967 and remains in operation today. (Photograph by Horace Chaffee, August 12, 1918.)

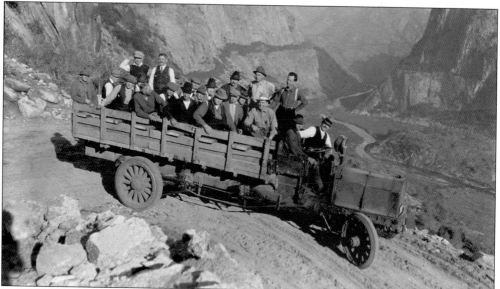

Workers brave their way to the construction site at Lake Eleanor in 1920 along the rough road that overlooks the steep Hetch Hetchy Valley and Tuolumne River. (Photograph by Horace Chaffee, October 10, 1918.)

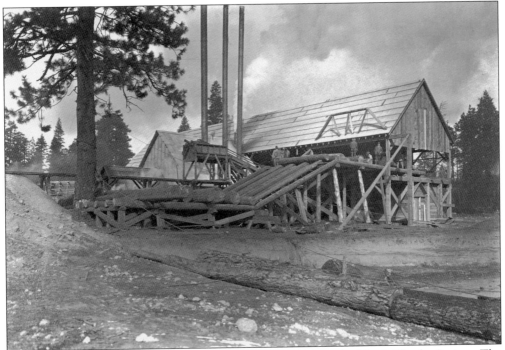

Two sawmills were created to provide the necessary timber for the Hetch Hetchy Project. The first mill was located at Canyon Ranch in 1915. Once the timber was exhausted, the mill was moved to Hog Ranch, pictured here in 1919. Known as Camp Mather today, this area is a summer recreational retreat owned and operated by the City and County of San Francisco. It is also the site of the very popular bluegrass Strawberry Music Festival that is held twice each year. (Photograph by Horace Chaffee, November 7, 1919.)

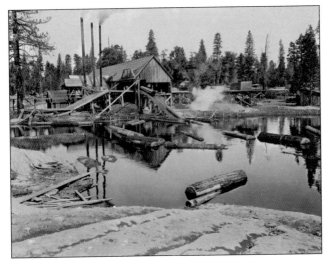

Camp Mather, located within the boundaries of Stanislaus National Forest, was so named by Michael O'Shaughnessy after Stephen T. Mather, the first director of the National Park Service. Camp Mather became an official recreational park in 1924, funded and operated by San Francisco's playground commission due largely to the efforts of supervisor Margaret Mary Morgan, the first woman elected to the San Francisco Board of Supervisors. (Photograph by Horace Chaffee, August 15, 1921.)

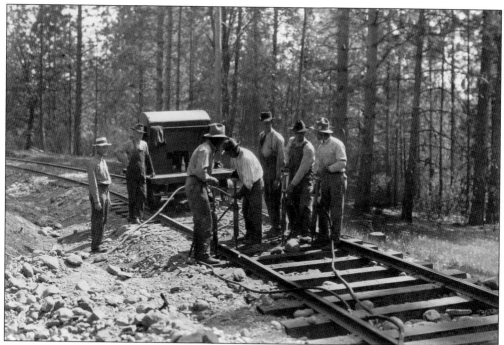

Construction of the 68-mile-long, narrow-gauge HHRR began immediately after the passage of the Raker Act. Transportation of workers and supplies to the mountainous terrain to construct the dam was the first priority. In 1925, the contract to build the railroad was awarded to Frederick Rolandi, who had been an engineer for the Chicago, Milwaukee, St. Paul & Pacific Railroad. Railroad construction crews, pictured here, used homemade, self-propelled tie tampers made from compressed-air devices. (Photograph by Horace Chaffee, May 10, 1919.)

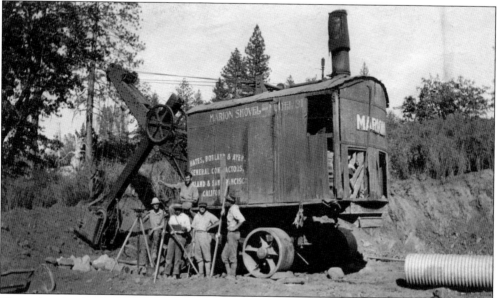

The only other heavy equipment used in building the railroad were two Marion steam shovels that helped by transporting ballast and excavating a navigable railroad grade. The 900 railroad workers, with their bedrolls in tow, laid the tracks and slept at the construction site.

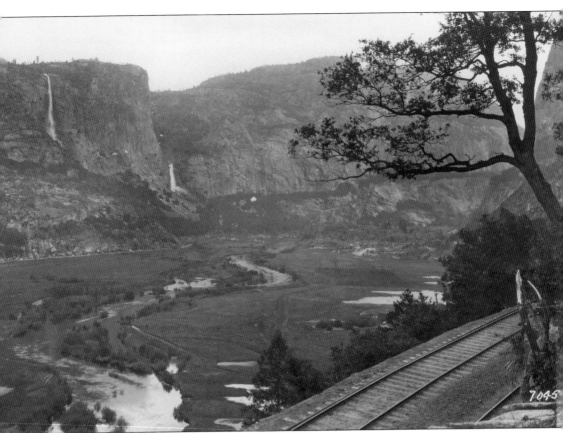

The HHRR mainly followed the course of the Tuolumne River from the dam site to Hetch Hetchy Junction where it linked with Sierra Railroad, approximately 26 miles east of Oakdale. Upstream, above the track adjacent to the dam site, the seasonal Tueeulala and Wapama Falls are visible in the background in Hetch Hetchy Valley, usually at their peak during runoff in late spring and early summer. Yosemite National Park is renowned for its spectacular waterfalls, including Yosemite Falls, located in Yosemite Valley. It is the highest waterfall in North America and the sixth highest in the world. (Photograph by Horace Chaffee, around 1921.)

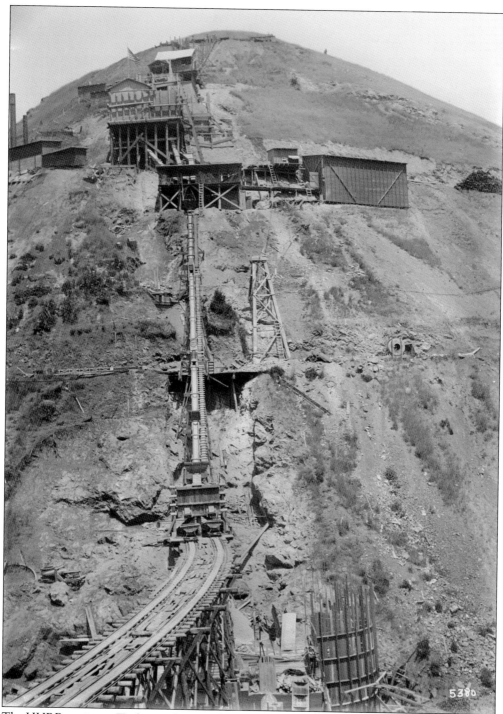

The HHRR station at Tuolumne Canyon showed how treacherous and steep the terrain was with its rock-rolled grade. This image illustrates why only a train could transport heavy materials and passengers around the clock. (Photograph by Horace Chaffee, 1918.)

The HHRR Engine No. 1 was a two-truck Heisler Locomotive purchased secondhand from a lumber company. The car, pictured here with Michael O'Shaughnessy seated in the front next to the unidentified driver, transported the chief and his crew from the dam construction site to the valley floor. One of the many challenges of operating the railroad was the lack of water to refill the boilers that ran the locomotives. Elevated water tanks had to be placed strategically along the track to avoid turning back for water. (Photograph by Horace Chaffee, August 11, 1918.)

The HHRR owned six steam locomotives and leased eight more from wherever they could be found during World War I. This was a railroad operated by city engineers instead of railroad professionals and featured innovations more akin to a busy thoroughfare. Here, the train rounds the bend into the Big Creek area, carrying passengers and supplies. When the railroad was dismantled in 1949, some of the materials were recycled and installed as guardrails along the steep mountain roads. (Photograph by Horace Chaffee, August 14, 1918.)

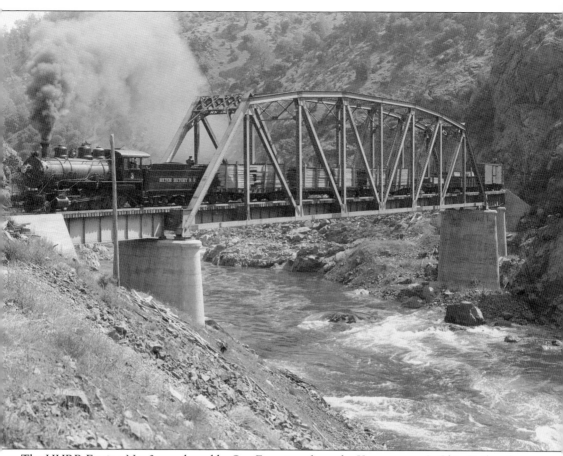

The HHRR Engine No. 3, purchased by San Francisco from the Youngstown & Ohio Railroad, crosses the Tuolumne River carrying a load of milled lumber on a clear span of just 20 feet. The bridge was located a short distance from the Eagle Shawmut gold mine that today lies under the waters of Lake Don Pedro. (Photograph by Horace Chaffee, May 10, 1919.)

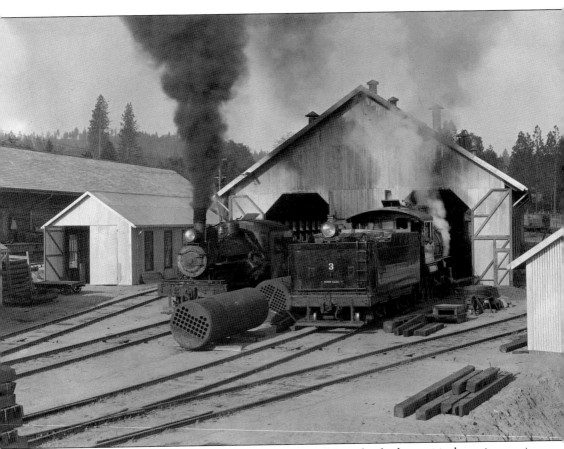

The HHRR maintenance yard was located in the town of Groveland, where critical ongoing repairs were conducted on the locomotives and cars. (Photograph by Horace Chaffee, May 10, 1919.)

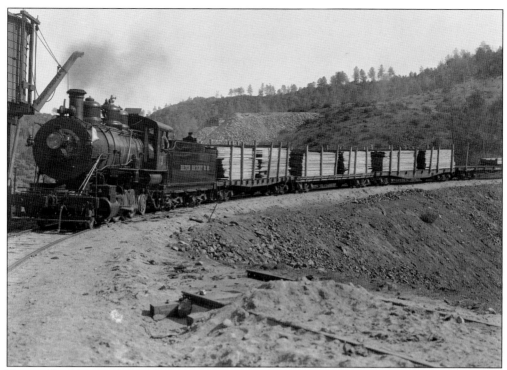

Engine No. 3 hauls a full load of timber as it rounds the steep curve into the gulch at Rattlesnake Creek. A portion of one of the large water tanks, which replenished the boiler to run the engine, is visible on the far left. (Photograph by Horace Chaffee, May 10, 1919.)

The HHRR was known for its diverse number of railroad cars and was featured in many media publications for its efficient track cars and buses. They were large cars built on a truck chassis that had been reinforced with custom undercarriage work. These cars mostly transported visitors and workers to the dam site. Track Car No. 19 was a converted White Motor Company bus that also served as the ambulance. (Photograph by Horace Chaffee, January 22, 1920.)

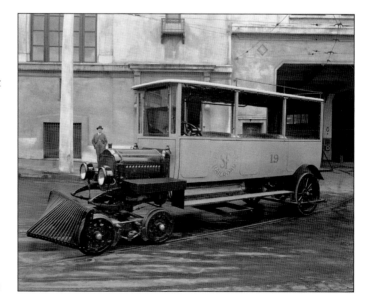

45

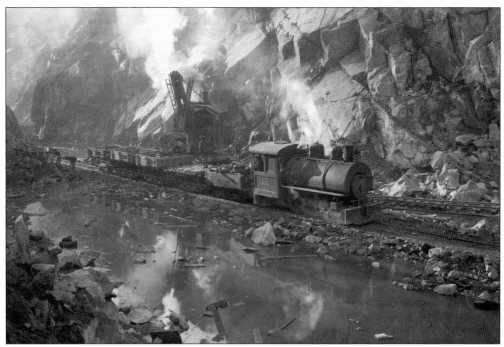

The HHRR was vital to the excavation at O'Shaughnessy Dam. Workers loaded granite rock, some of which was crushed and added in the concrete to build the dam. In this photograph, excavation is aided by a steam shovel. (Photograph by Horace Chaffee, December 14, 1920.)

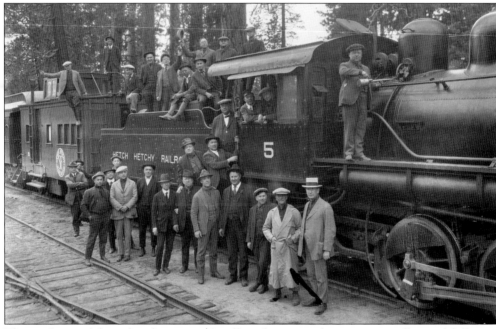

The total cost of the railroad came to $2 million, but it saved many more millions of dollars in hauling cement alone. Engine No. 5 brought workers and visitors to the construction area on its twice weekly run from the South Fork of the Tuolumne River to the dam construction site. (Photograph by Horace Chaffee, 1921.)

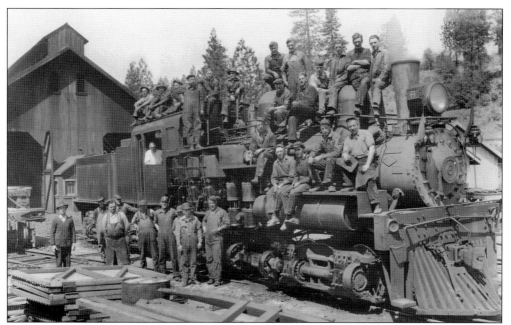

The roundhouse crew at the Groveland maintenance yard epitomized the "Hetch Hetchy spirit." They pose here with Engine No. 6, a Shay Locomotive invented in 1880 by engineer and Civil War veteran Ephraim Shay for his Michigan logging business. Engine No. 6 carried supplies up the notoriously steep Priest Grade. This engine was retired and later donated to Yosemite National Park. It is on display in El Portal, California. The Shay Locomotives were the unsung heroes of the HHRR, as they adeptly maneuvered steep curves while carrying heavy loads of concrete and lumber. (Photograph by Horace Chaffee, May 3, 1922.)

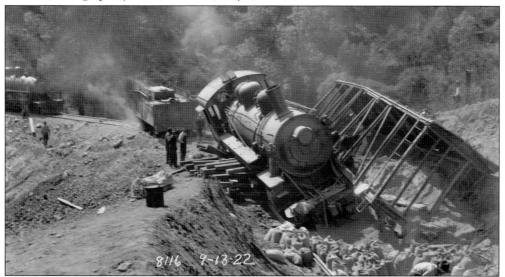

HHRR Engine No. 4 crashed after rushing down the steep grade toward the Six Bit Trestle. A new brakeman may have erred and caused the train to run away, after which the wreckage caught fire. Sadly, the brakeman was killed, but others managed to jump to safety, sustaining minor injuries. Warning whistles gave work crews time to stand clear. Overall, the HHRR had an outstanding safety record. (Photograph by Horace Chaffee, September 13, 1922.)

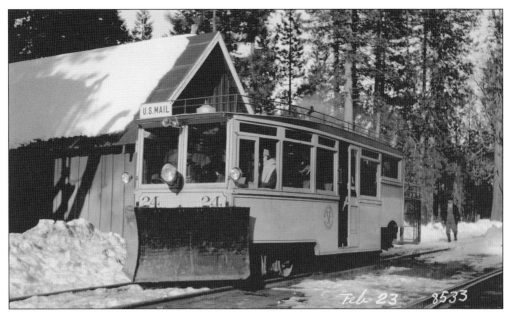

The utilization of approximately 16 track cars and buses operated by gasoline engines gave the HHRR enhanced flexibility to navigate the challenging terrain. The first track car created by HHRR was a converted Cadillac. Track Bus No. 24, pictured here, delivered mail and as many as 32 passengers and operated its snowplow whenever necessary. Most of the track cars and buses were sold or scrapped in 1949. (Photograph by Horace Chaffee, February 23, 1923.)

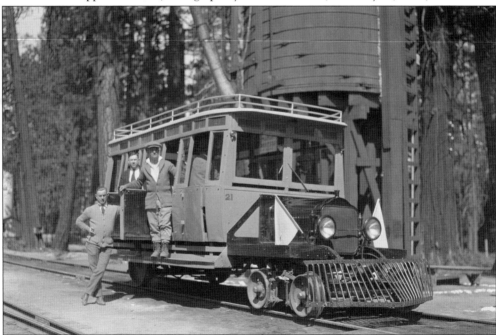

This photograph from Camp Mather shows Track Car No. 21, which had a 27-person capacity and a baggage rack on the back. It was noted for being one of the two fastest track cars. One of the tall wooden tanks that store the water needed for the boilers on the locomotives is visible in the background. (Photograph by Horace Chaffee, June 9, 1924.)

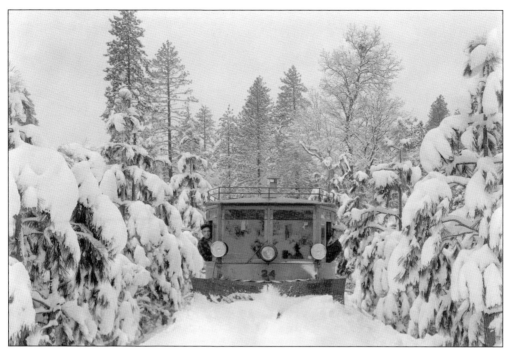

This photograph, taken two miles west of Jones Station, exemplifies the HHRR as the proverbial workhorse as it plowed through the deep snow. The railroad allowed the construction to continue nonstop. This made it possible to complete the construction of O'Shaughnessy Dam in just four years. (Photograph by Horace Chaffee, January 7, 1930.)

Located in the Sierra Nevada foothills, the quaint gold rush town of Groveland, with a population of 300 people, was a hub of activity from 1916 to 1924, when the Hetch Hetchy Project set up headquarters in the buildings pictured here. Today, residents of Groveland enjoy high-quality water from the Hetch Hetchy aqueduct. (Photograph by Horace Chaffee, August 6, 1918.)

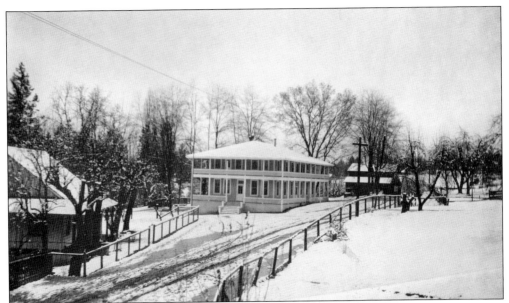

Located in Groveland along what is today the Highway 120 corridor to Yosemite National Park, this building was the administration office for the Hetch Hetchy Project. (Courtesy of Thomas F. Van Alstyne, around 1920.)

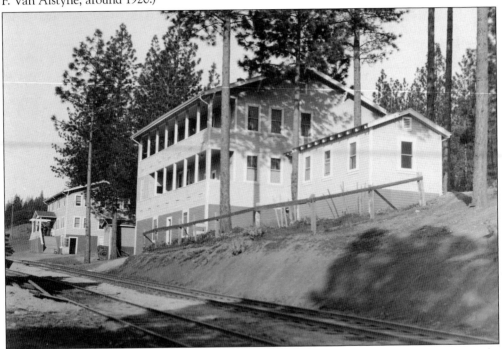

The hospital, built by the City and County of San Francisco in Groveland, provided services for the sick and injured during the Hetch Hetchy Project and also functioned as the clubhouse in the 1920s. Groveland was the proud home to a baseball team with professional uniforms, whose players came mainly from the Hetch Hetchy Project. For nearly five years, the baseball team, a member of the Mother Lode League, was a major form of entertainment in Groveland and a favorite pastime for Chief O'Shaughnessy.

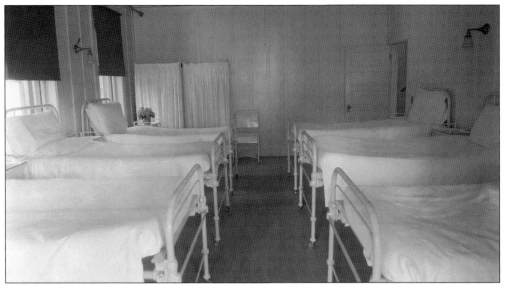

This was the large ward of the hospital built in Groveland in 1919 primarily for the Hetch Hetchy workers. The highly revered Dr. John P. Degnan, born in Yosemite Valley, was responsible for medical services provided for the workers and their families from 1921 to 1934. Degnan gained notoriety and inspired great confidence for his dedication. Reportedly, he once commandeered and drove a Hetch Hetchy locomotive through a blinding snowstorm to deliver a baby on the outskirts of Groveland. (Photograph by Horace Chaffee, May 10, 1919.)

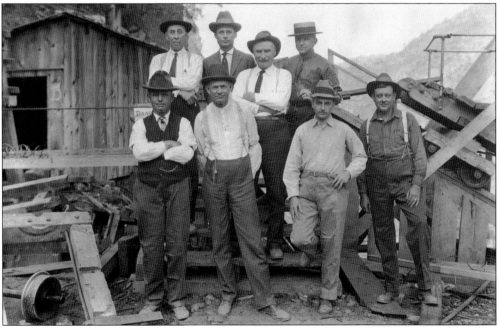

Michael O'Shaughnessy, with arms folded and wearing a white shirt and tie, is pictured in the middle of this group at the top of the very steep tramway on the dam. Two tramway systems at Hetch Hetchy Reservoir served as cliffside "elevators" during construction, transporting workers and supervisors to and from the work sites with a drop in elevation of 300 feet. (Photograph by Horace Chaffee, August 28, 1919.)

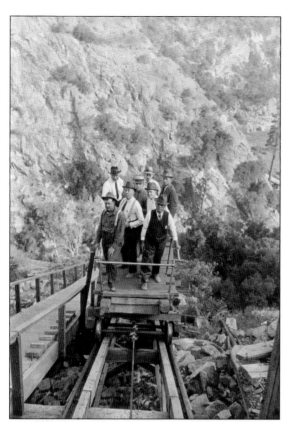

Michael O'Shaughnessy stands in the left rear of this group of officials on the tramway accompanying the Wattis brothers, founders of Utah Construction Company, which was awarded the contract to build the dam at Hetch Hetchy Reservoir. The construction of O'Shaughnessy Dam proved so successful that Utah Construction Company went on to build 58 more dams from 1916 to 1969. It formed a conglomerate and won the massive contract to build the Hoover Dam, now in Lake Mead National Recreation Area. (Photograph by Horace Chaffee, August 28, 1919.)

Early Intake Powerhouse provided electricity for the mountainside tramways, also known as incline cable railways. The longest Hetch Hetchy Project tramway was built in 1918 on the cliff above Early Intake Powerhouse. From the railroad down to the valley floor, there was a drop in elevation of 3,700 feet. (Photograph by Horace Chaffee, May 9, 1919.)

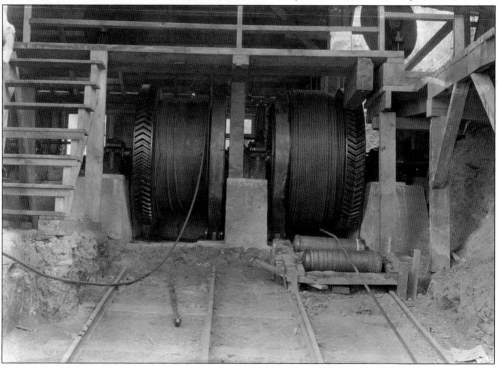

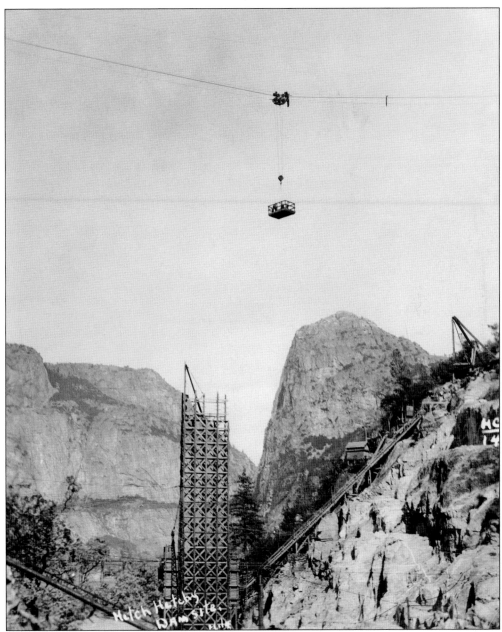

Construction of O'Shaughnessy Dam was finally underway in 1919, after the completion of the necessary infrastructure including the Early Intake Powerhouse, Hog Ranch Sawmill, and the HHRR. The tall timber tower in the center of the photograph was used to pour concrete. In the background to the right of the tower is Kolana Rock; to the left of the tower is Hetch Hetchy Dome. (Photograph by Lewis F. Hile, around 1919.)

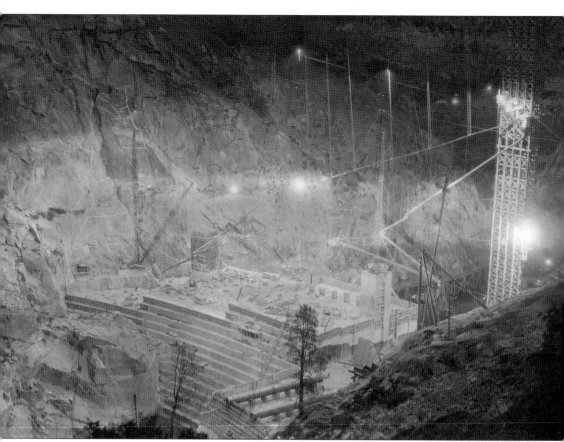

A dramatic photograph of night construction at the dam illustrates the complexity of the Hetch Hetchy Project. (Photograph by Horace Chaffee, June 6, 1922.)

It took four years of pouring concrete day and night to complete the first phase of construction. Night construction, seen here in 1922, was unusual for the era. (Photograph by Horace Chaffee, June 6, 1922.)

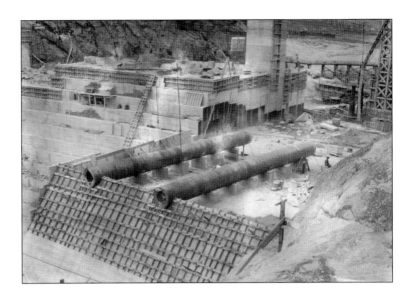

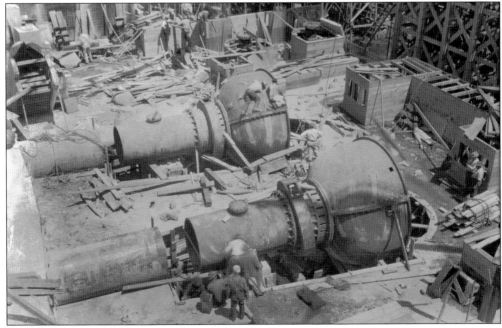

Workers installed the gigantic outlet conduits and valves at the dam to control water releases into the Tuolumne River, sustaining wildlife and recreational activities, including rafting and fishing. Today, the SFPUC works in partnership with Tuolumne River rafting companies regarding river flows to ensure the integrity of the renowned whitewater runs. In some places, the Tuolumne River runs are Class V difficulty and require advanced skills. (Photograph by Horace Chaffee, June 29, 1922.)

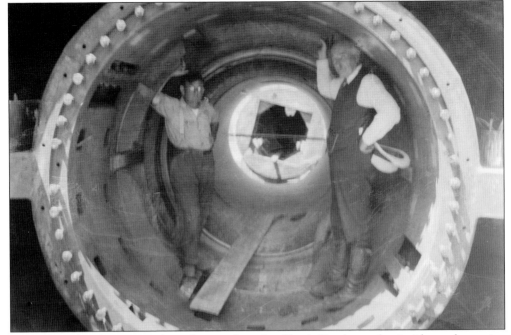

Michael O'Shaughnessy, on the right, stands with a Hetch Hetchy worker inside a valve casing for a conduit awaiting installation at the dam site. Water from the reservoir can be released from the dam through 14 different conduits. (Photograph by Horace Chaffee, June 29, 1922.)

Pictured is one of six balanced valves used in the construction of the dam. (Photograph by Horace Chaffee, around 1922.)

The same contractor supplied additional balanced valves that were 36 inches in diameter, also used in dam operations. (Photograph by Horace Chaffee, around 1922.)

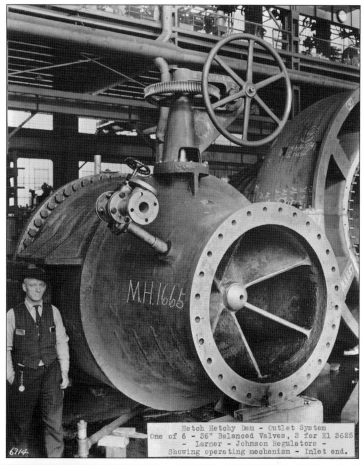

Hetch Hetchy Dam - Outlet System
One of 6 - 36" Balanced Valves, 3 for El 3625
- Larner - Johnson Regulators -
Showing operating mechanism - Inlet end.

Workers constantly negotiated the steep terrain while laying pipeline. Falls from heights were one of the main causes of work-related accidents. According to the Tuolumne County coroner, 12 out of the 89 deaths during construction were due to falls. (Photograph by Horace Chaffee, April 17, 1922.)

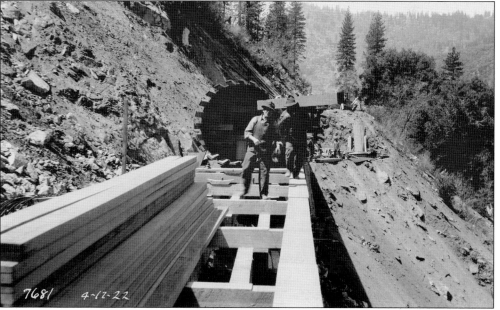

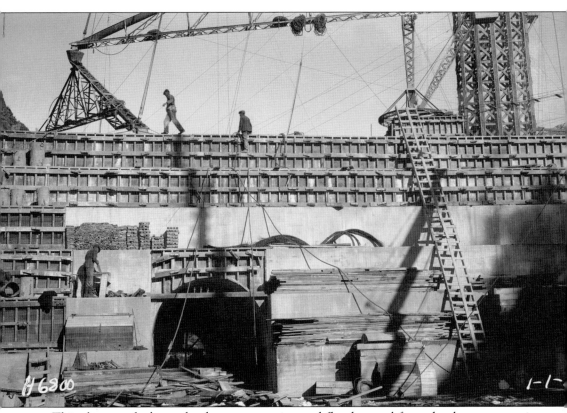

This photograph shows the dam construction and flood tunnel from the downstream view. (Photograph by Horace Chaffee, January 1, 1922.)

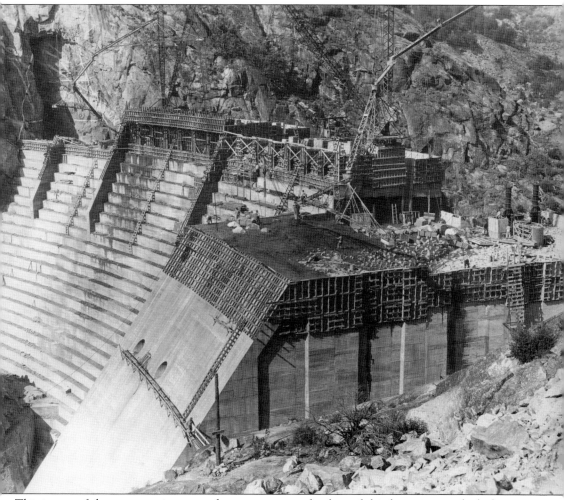

This image of the construction was taken upstream at the face of the dam, six months before completion. Concrete pouring continued through the chutes and pipes from the tall, timber placement tower. Large boulders and smaller granite rocks from the excavation were added to the concrete mix to fortify the structure. (Photograph by Horace Chaffee, September 26, 1922.)

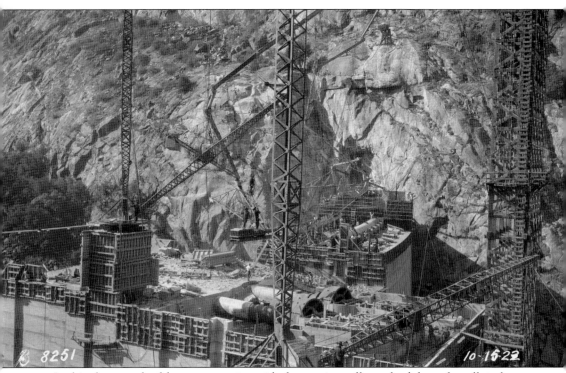

In this photograph of dam construction with the granite walls as a backdrop, the tall timber tower on the right stands more than 35 stories high. It directed and poured concrete through eight-inch-diameter pipes from a higher elevation downward to different segments of the construction, using gravity to its advantage. (Photograph by Horace Chaffee, October 15, 1922.)

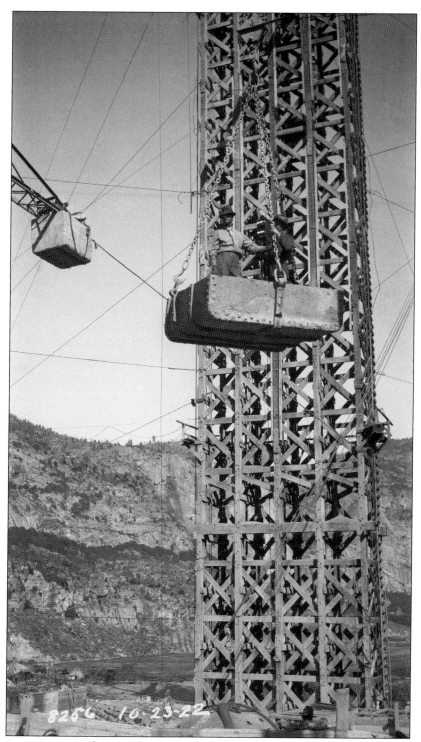

Workers were transported primarily via an elaborate, overhead cable system at the dam. Here, they are pictured crossing in front of the massive timber tower. (Photograph by Horace Chaffee, October 23, 1922.)

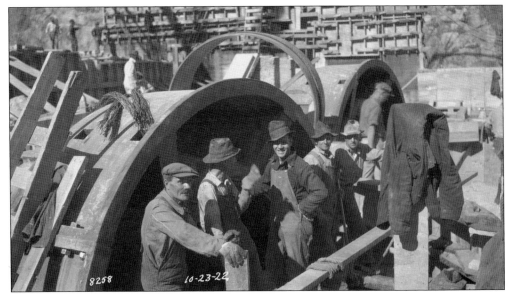

A group of workers at O'Shaughnessy Dam gathers next to the conduits awaiting installation. (Photograph by Horace Chaffee, October 23, 1922.)

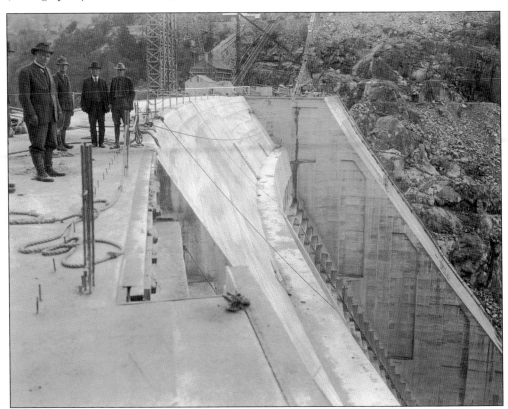

Six months before completion of the first phase of construction of the dam, Chief O'Shaughnessy stands atop the structure with several supervisors, overlooking the downstream face of the dam. (Photograph by Horace Chaffee, January 18, 1923.)

Dedication festivities for the celebration of the completion of the dam were held on July 7, 1923, at Hetch Hetchy Reservoir. Mayor James Rolph hailed Michael O'Shaughnessy "as more than a scientist and a builder, and as one of the great souls of our generation." O'Shaughnessy Dam was proclaimed the largest structure on the West Coast at the time and a monument to the genius of Michael O'Shaughnessy. (Photograph by Horace Chaffee.)

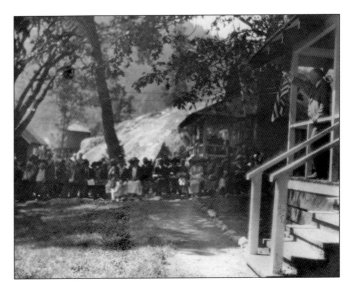

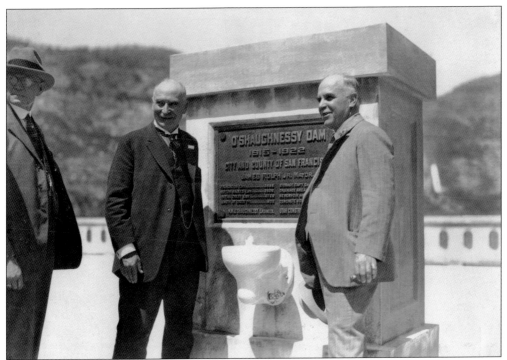

Michael O'Shaughnessy (center) and Mayor James Rolph (right) pose in front of the large commemorative plaque and water fountain during the dedication of O'Shaughnessy Dam. This same year, the Bay Area experienced a severe drought and East Bay Municipal Utility District began construction of its water system utilizing the Mokelumne River watershed in the Sierra Nevada. The man at left is unidentified. (Photograph by Horace Chaffee, July 7, 1923.)

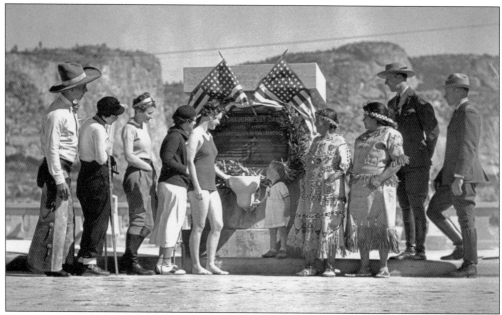

This group photograph was taken at the dedication in front of the drinking fountain and commemorative plaque on top of O'Shaughnessy Dam on July 7, 1923.

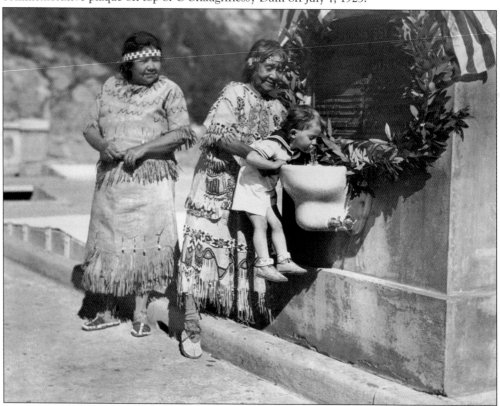

Native Americans offered much-needed assistance at the ceremony at Hetch Hetchy Reservoir on July 7, 1923.

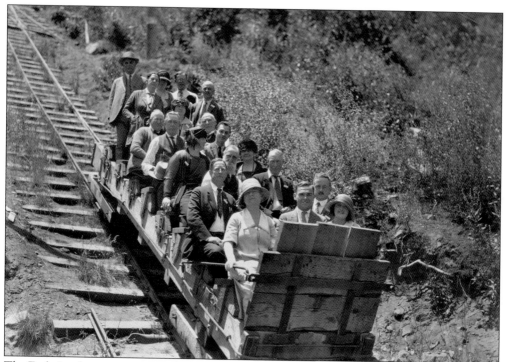

The Early Intake tramway carried elected officials and guests on the second day of festivities after the dedication to the powerhouse. Annie Rolph, the mayor's wife, is seated in the front wearing a white dress. (Photograph by Horace Chaffee, July 8, 1923.)

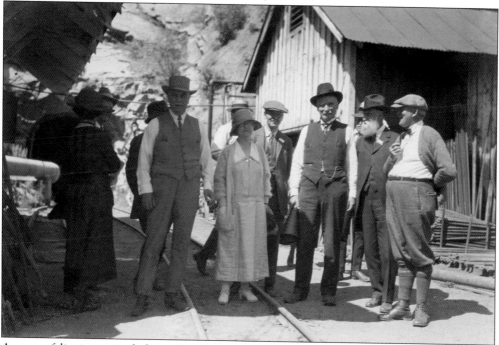

A group of dignitaries, including Mayor James Rolph and his wife, toured Early Intake Powerhouse, escorted by Michael O'Shaughnessy. (Photograph by Horace Chaffee, July 8, 1923.)

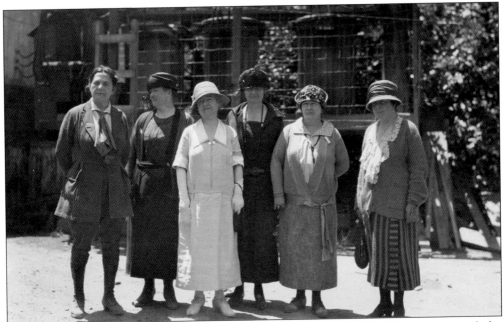

This group of female guests, shown after the dedication at Early Intake Powerhouse, includes San Francisco supervisor Margaret Mary Morgan, who championed the establishment of Camp Mather for long-term recreation. Morgan is on the far left; Annie Rolph is third from the left, in the white dress. (Photograph by Horace Chaffee, July 8, 1923.)

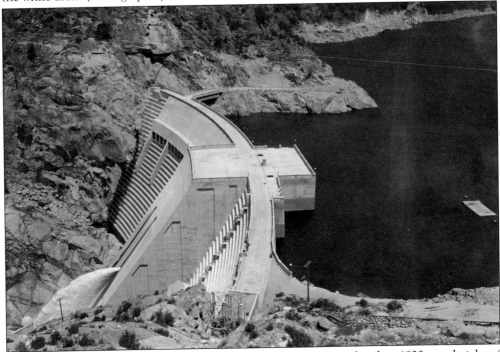

The first phase of construction of O'Shaughnessy Dam was completed in 1923 to a height of 226.5 feet with a capacity of 206,000 acre-feet of water. The next step was construction of the 160-mile-long aqueduct to the Bay Area. (Photograph by Horace Chaffee, June 9, 1924.)

During the second phase of construction in 1938, O'Shaughnessy Dam was raised 85.5 feet to its current height using steel anchors between the new and old concrete. The appearance of the face of the dam changed dramatically. It is a gravity-arch design, approximately 900 feet in length, with a capacity to impound 360,360 acre-feet of water in the Hetch Hetchy Reservoir.

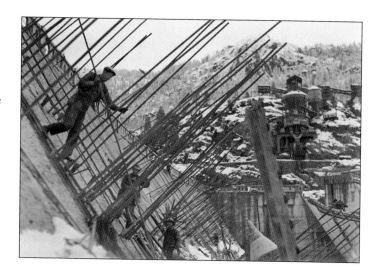

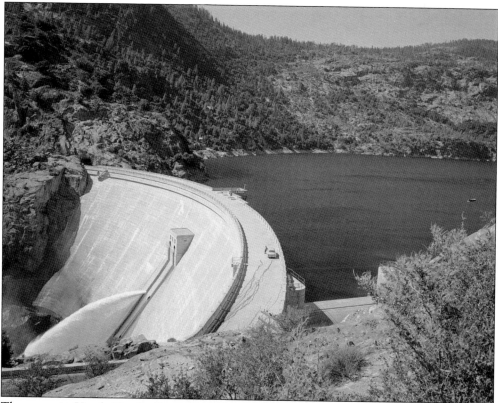

The water in Hetch Hetchy Reservoir does not require filtration. It is one of only six major water systems in the country that operates with a filtration exemption from the Environmental Protection Agency. This exemption is maintained through vigilant protection of the source water by a partnership with the Yosemite National Park staff and city workers. In order to retain the filtration exemption from the Environmental Protection Agency, no one is permitted in the waters of the Hetch Hetchy Reservoir. (Photograph by Marshall Moxom, June 25, 1959.)

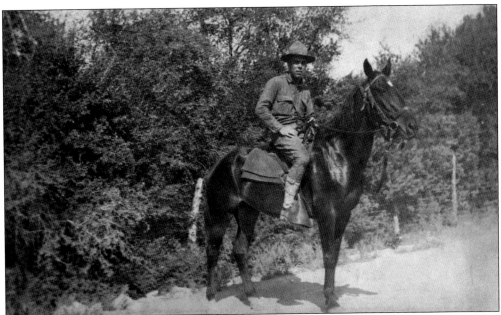

E.R. Bottimore, watershed keeper, patrolled on horseback in 1924. Watershed keepers and park rangers are charged with protecting the Tuolumne River watershed lands. Today, the SFPUC has adopted watershed management plans that have been vetted through years of public hearings.

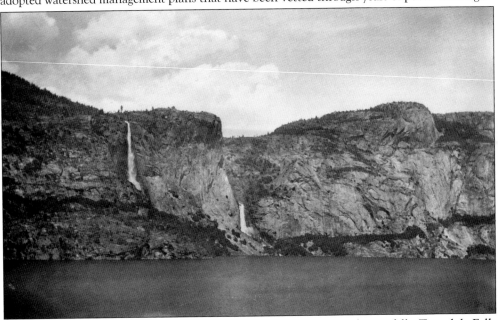

Hetch Hetchy Reservoir is pictured here with its two largest seasonal waterfalls: Tueeulala Falls on the left and Wapama Falls on the right. The falls are usually fullest in late spring and early summer. Visitors to the reservoir can reach the falls via a trailhead that starts at O'Shaughnessy Dam for an easy, four-hour round-trip hike along the rim of the reservoir. SFPUC partners with the National Park Service to maintain and protect the area. The city has provided millions of dollars in funding each year for maintenance and additional rangers in the Tuolumne River watershed. (Courtesy of the USGS, 1936.)

Four

Mountain Tunnel to Moccasin

The construction of the first leg of the aqueduct from Hetch Hetchy Reservoir to the Moccasin Powerhouse was the 19-mile-long Mountain Tunnel. Bids for the construction from outside contractors had been too inflated for Michael O'Shaughnessy, who was known for his parsimonious scrutiny of expenses. So, he set out to build the tunnel with city employees. Camps consisted of wood cabins with stoves and provided plentiful food by good cooks. It was grueling work, and O'Shaughnessy wanted to keep his best workers comfortable. They became excellent tunnelers, working 24 hours a day under the supervision of Hetch Hetchy legend Pete Peterson.

The workers, some of whom had years of rigorous tunneling experience from as far away as Sweden, drilled and blasted from 12 faces, or points, "holing through" to connect with each segment. Four of the 12 working faces included the Big Creek and Garrote (the name for Groveland until 1875) shafts. Garrote Shaft was fraught with flooding problems and required a great amount of time and effort during excavation. Construction of the Mountain Tunnel was an enormously challenging feat, with 38 percent of the 19-mile-long tunnel excavated through solid granite. It was constructed to deliver a capacity of 400 million gallons per day. Two portals built in the tunnel carry water to the Priest Reservoir, where it flows into the giant Moccasin penstocks that are anchored to the mountainside. The penstocks subsequently deliver water under great pressure to the Moccasin Powerhouse to create hydropower.

The town of Moccasin began to evolve with the establishment of small homes, offices, powerhouses, facilities for the ongoing power operations, and the maintenance of the water and power facilities in the Sierra Nevada and foothills. It is one of the few company towns still in existence in California, with approximately 40 families paying market rate for their rent of modest but comfortable cottages. The City and County of San Francisco is one of the largest employers in Tuolumne County, where jobs with great benefits are in short supply.

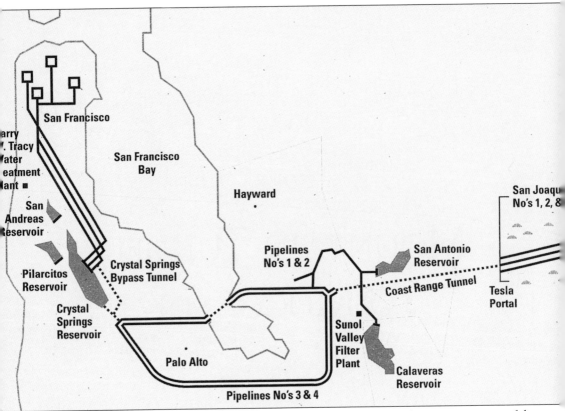

This simplified schematic of the Hetch Hetchy system from 2002 shows the major segments of the 160-mile-long aqueduct from the Sierra Nevada to the Bay Area. This configuration will change

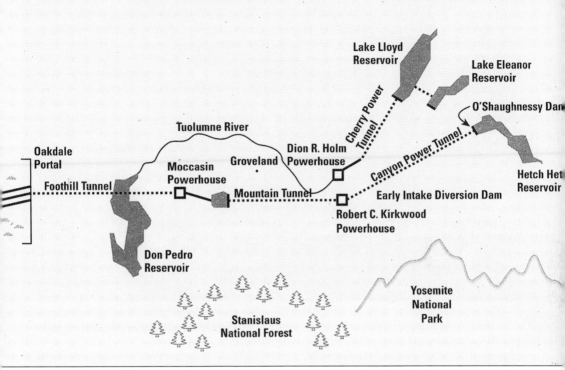

in 2016 with the completion of the current capital campaign, which will add three new tunnels, including one that will be built under the bay.

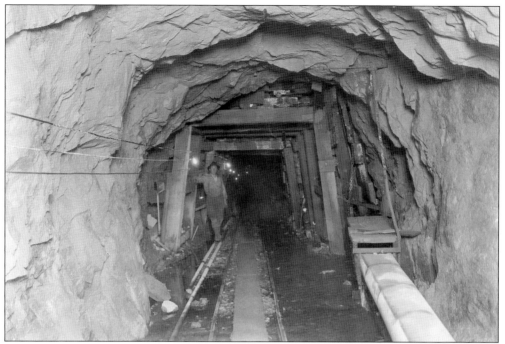

A tunneler, colloquially called a miner, stands inside the unlined South Fork Tunnel that was 14.5-feet in diameter and 376-feet long. It was one of 14 sections that comprised Mountain Tunnel constructed in 1918. (Photograph by Horace Chaffee, August 8, 1918.)

Big Creek compressor plant operated at Big Creek Shaft, where tunnel rock was brought to the surface through the shaft. The shaft was 646 feet deep during the excavation of Mountain Tunnel. Rock then was crushed and used for ballast and building or repairing roads. (Photograph by Horace Chaffee, August 13, 1918.)

Excavation at the Second Garrote Shaft was the biggest challenge in building the Mountain Tunnel. It was not anticipated that water with a volume of 2,000 gallons per minute would come gushing out of the shaft during construction. Pump stations had to be installed in sumps at various levels adjacent to the shaft site. It was as if an underground river had been tapped. (Photograph by Lewis F. Hile, around 1922.)

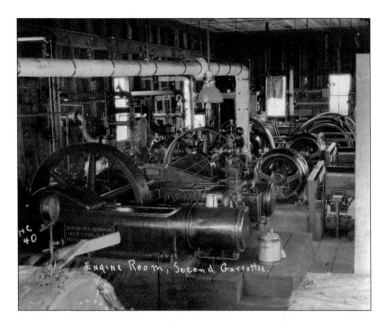

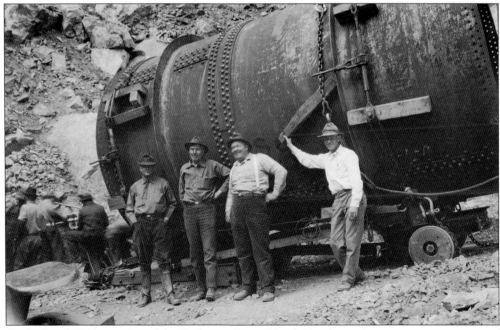

At the South Fork crossing of the Tuolumne River, Hetch Hetchy workers transport a segment of pipeline that measures 9.5 feet in diameter. (Photograph by Horace Chaffee, March 20, 1925.)

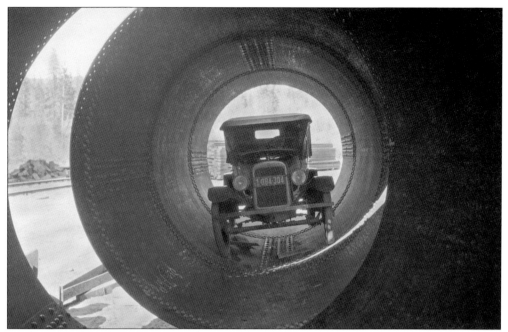

Workers placed a car inside a pipe to show the massive scale of the pipeline at South Fork crossing. (Photograph by Horace Chaffee, March 20, 1925.)

The tunnel crew built a mile-long tunnel at Priest Reservoir. This is a regulating reservoir that feeds water under great pressure into the Moccasin penstocks. This regulating reservoir provides flexibility to maximize hydropower generation at Moccasin. (Photograph by Horace Chaffee, April 27, 1922.)

A surveyor stands on the left at the opening to the Moccasin Power Tunnel at the Priest Reservoir as he watches the muck train removing excavated rock. There was continuous checking by Hetch Hetchy surveyors and engineers to ensure the tunnel sections were staying in alignment so that they would connect. (Photograph by Horace Chaffee, September 25, 1922.)

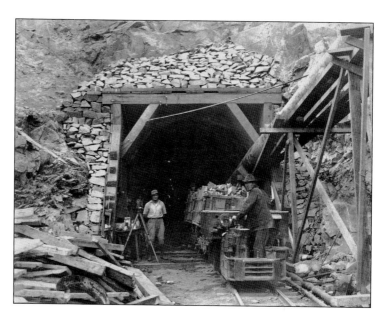

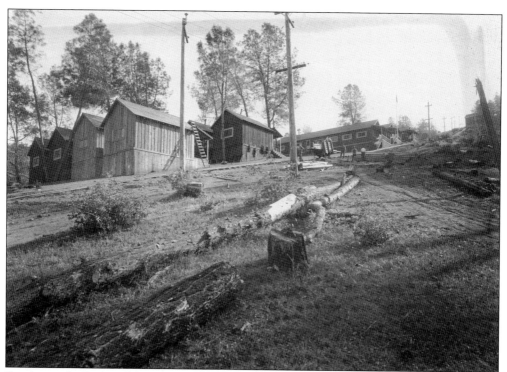

Sturdy wood cabins at Priest Camp were built to improve conditions for the workers. One of the many camps for the Mountain Tunnel construction was built in the gorge near the South Fork of the Tuolumne River on such steep terrain that water washed away part of the camp on one occasion. Workers had to use a small tractor to access the area. (Photograph by Horace Chaffee, May 9, 1919.)

This c. 1918 photograph shows a light and happy moment at the workers camp with a thriving litter of puppies. (Courtesy of Thomas F. Van Alstyne.)

This c. 1917 photograph from the personal album of a Hetch Hetchy worker shows women identified only by their first names, from left to right, as Dolly, Margie, and Clyde. Clyde was the telephone operator for the Hetch Hetchy Project. (Courtesy of Thomas F. Van Alstyne.)

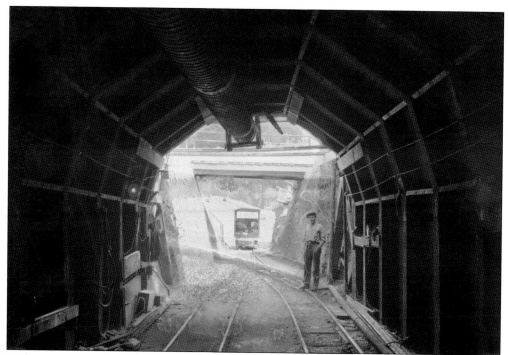

Multiple construction projects were underway simultaneously. Construction of the Moccasin facility in the foothills occurred during the same period as the construction of the Pulgas Water Temple and Tunnel, pictured here at the east portal on the peninsula. Work was occurring simultaneously on the Bay Division Pipeline No. 1 in the Bay Area as well. (Photograph by Horace Chaffee, September 21, 1922.)

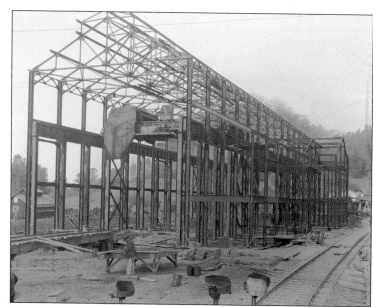

The original Moccasin Powerhouse, under construction at the junction of California Highways 120 and 49, was approximately 225 feet long and was situated adjacent to Moccasin Creek. It was designed in the Mission style of architecture with arched arcades and a tile roof. (Photograph by Horace Chaffee, December 7, 1923.)

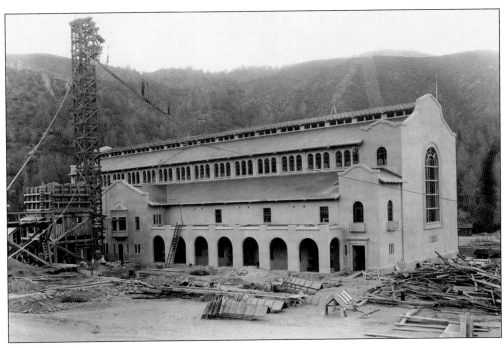

These photographs show two views of the 1925 Moccasin Powerhouse, which operated until 1969. That year, a new Moccasin Powerhouse was built adjacent to the 1925 building. Today, the Hetch Hetchy Project operates three powerhouses and generates 1.7 billion kilowatt hours of electricity—enough power for 200,000 homes. In San Francisco, 20 percent of the overall electricity consumed is generated by the Hetch Hetchy hydropower system. This powers municipal services, including hospitals, transportation, libraries, city hall, and streetlights. (Above, photograph by Horace Chaffee, September 27, 1924; below, photograph by Horace Chaffee, September 12, 1925.)

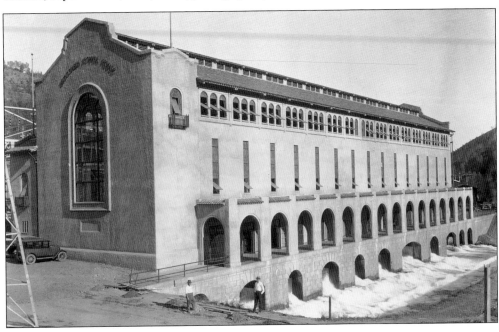

The Moccasin penstocks, built in 1924 for $2.5 million, are enclosed pipelines that deliver water to the powerhouse. The pressurized water in the penstocks spins the turbines in the powerhouse to create hydropower. Construction of the giant penstocks was difficult due to the heavy, pressurized pipe that had to be raised and placed on the steep hillside. (Photograph by Horace Chaffee, September 3, 1924.)

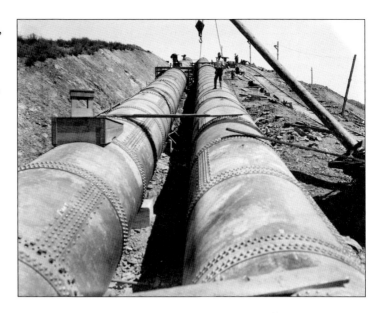

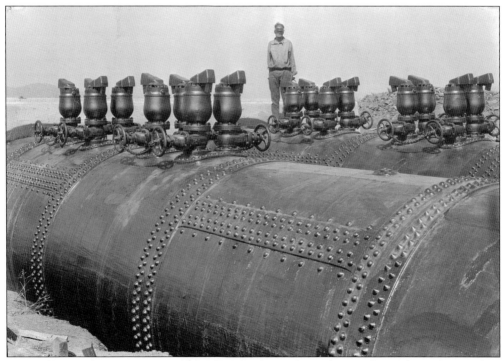

Pictured here is the Moccasin Powerhouse penstock air valve with a Hetch Hetchy worker standing on top of the riveted pipeline. (Photograph by Horace Chaffee, September 12, 1925.)

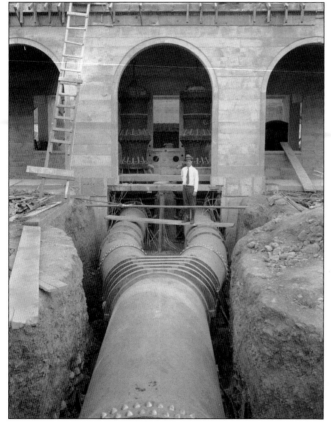

The completion of O'Shaughnessy Dam had generated curiosity and excitement and was a great source of pride for its many employees and the citizens of San Francisco. San Franciscans could visit the dam on the weekend for $30, including meals, bunkhouse accommodations, and transportation via the railroad. Many elected officials, like supervisor and acting mayor J. Emmet Hayden, pictured here driving a rivet, visited the construction sites. Reporters frequented the project over the 20-year period. (Photograph by Horace Chaffee, August 22, 1925.)

Moccasin Powerhouse penstocks were joined with a Y-branch connection underground at the powerhouse. (Photograph by Horace Chaffee, April 29, 1924.)

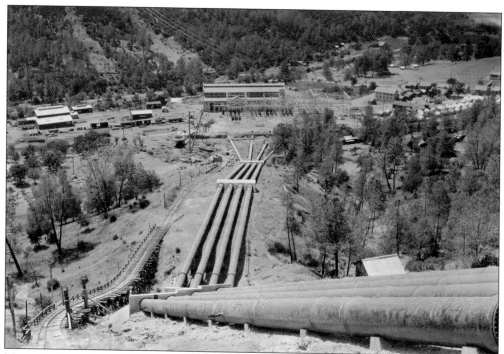

Moccasin Powerhouse rests at the bottom of the 5,349-foot-long penstocks. This photograph of the penstocks and the original Moccasin Powerhouse shows the 1,316-foot change in elevation. (Photograph by Horace Chaffee, August 22, 1925.)

Waterwheels awaiting installation in the Moccasin Powerhouse were purchased from the Pelton Water Wheel Company in San Francisco. (Photograph by Horace Chaffee, February 17, 1923.)

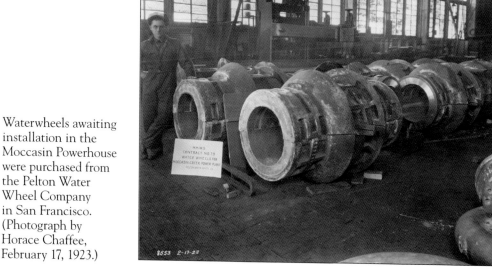

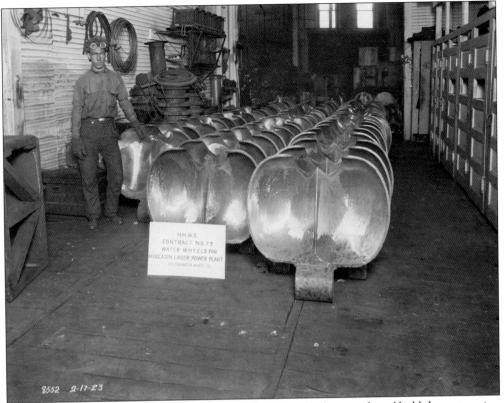

Giant buckets were attached on the perimeter of the waterwheels to catch and hold the water using the force of the water to turn the turbines. (Photograph by Horace Chaffee, February 17, 1923.)

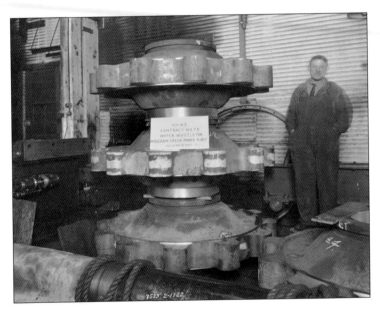

Another photograph displays parts from the Pelton Water Wheel Company vendor for the waterwheels. This was likely documentation for the meticulous contractual and financial control employed by O'Shaughnessy. (Photograph by Horace Chaffee, February 17, 1922.)

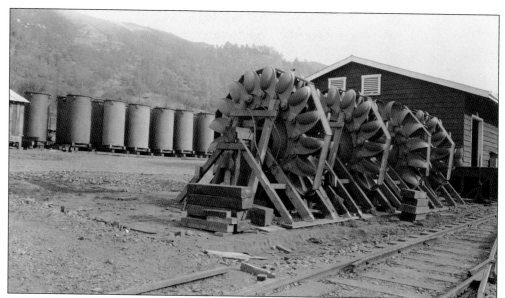

Waterwheels and transformers at Moccasin Powerhouse maintenance yard await installation during construction of the power facilities. When operational, a Pelton Water Wheel or turbine, pictured in the center at Early Intake, turns as the water shoots through the valves from the penstocks with great force and fills the large buckets on the perimeter of the wheel. This action turns the wheel at a very rapid rate. (Photograph by Horace Chaffee, December 7, 1923.)

An unidentified worker is seen here, with the wheel, also known as a turbine, stored on its side. Lester Allan Pelton, who established the Pelton Water Wheel Company of San Francisco, invented the Pelton wheel in 1888. Note the bucket-like extensions that fill with water. Pelton was a Civil War veteran who received his inspiration for the efficient waterwheel from his mining experience during the Gold Rush.

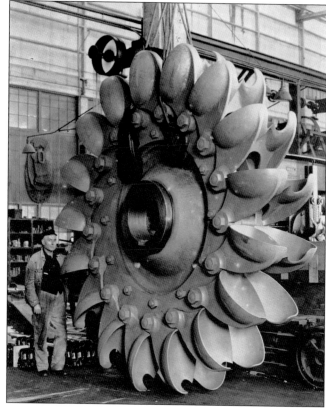

83

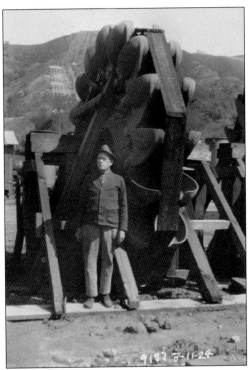

This Pelton Water Wheel was installed at Moccasin Powerhouse in 1924. A ghosted image of the penstocks under construction is in the background. They bring water from Priest Reservoir atop Priest Hill. The Pelton Water Wheel design is still used today at the Hetch Hetchy powerhouses. (Photograph by Horace Chaffee, March 11, 1924.)

This photograph shows the interior of the original Moccasin Powerhouse that housed its four massive generators and turbines. (Photograph by Horace Chaffee, May 12, 1932.)

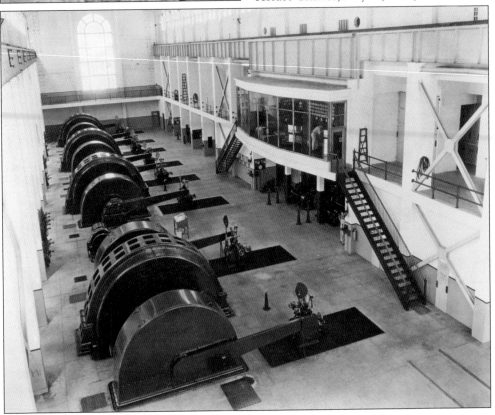

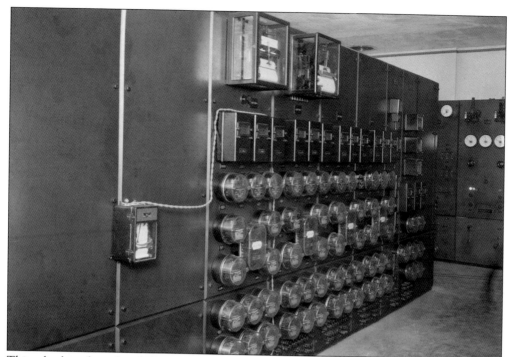

This relay board regulated electricity that was housed inside the original Moccasin Powerhouse. Running the SFPUC powerhouses requires skilled operators. (Photograph by Horace Chaffee, September 12, 1925.)

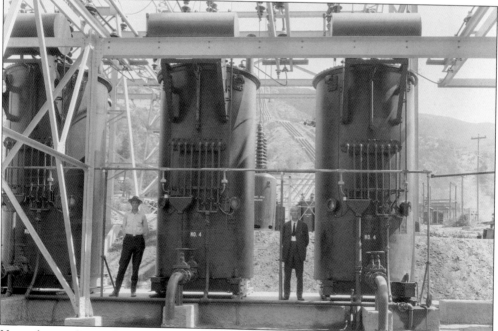

Huge electrical transformers are stationed outside the Moccasin Powerhouse. The penstocks anchored to the mountainside can be seen in the background between the two transformers on the right. (Photograph by Horace Chaffee, September 12, 1925.)

Moccasin Powerhouse supervisors have gathered outside on the hillside at the Moccasin switchyard for a group photograph. (Photograph by Horace Chaffee, January 21, 1926.)

All Hetch Hetchy electrical towers and rights-of-way, including this switch tower for the Hetch Hetchy power lines, are maintained by the SFPUC. The Hetch Hetchy power lines connect in the Bay Area at the Newark switchyard. (Photograph by Horace Chaffee, May 6, 1925.)

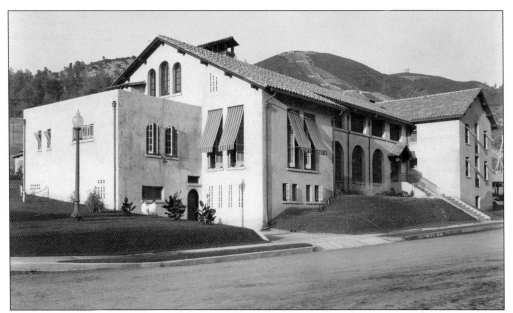

Today, the original Moccasin clubhouse and dormitory provides space for administrative offices, public stakeholder meetings, and work-related events, such as retirement dinners. (Photograph by Horace Chaffee, August 9, 1929.)

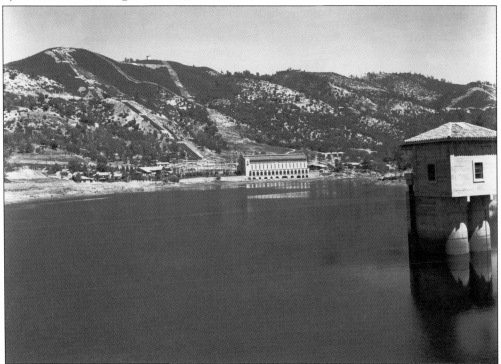

The Moccasin company town and powerhouse are located adjacent to the Moccasin Reservoir. The structure on the far right houses pipes and serves as a vault for valves. These valves open and close outlets in the reservoir for water releases as needed. This photograph was taken from atop the earth-filled Moccasin Dam. (Photograph by Horace Chaffee, 1935.)

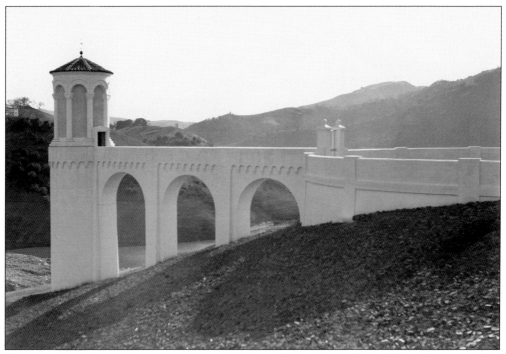

The original Calaveras Dam gate tower was built in 1925 by Spring Valley Water Company. The construction of the new Calaveras facilities is underway as part of the current capital campaign. This project, requiring many years of design, engineering, and review, has attracted some of the best dam engineers and scientists. The new dam will provide more seismically sound facilities in an area that is in proximity to the Hayward and Calaveras fault lines. (Photograph by Horace Chaffee, January 22, 1926.)

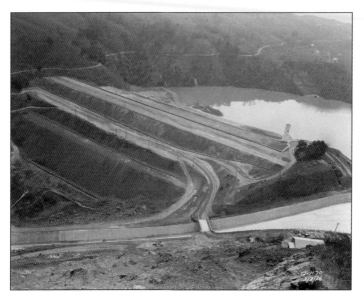

Calaveras Dam, located in the Alameda watershed, was owned and reconstructed by Spring Valley Water Company under the direction of William Mulholland in 1921 after it collapsed in 1918. Even though the work was not under his control, O'Shaughnessy kept close watch and routinely voiced his unsolicited opinions to influence the construction. (Photograph by George Fanning, March 3, 1926.)

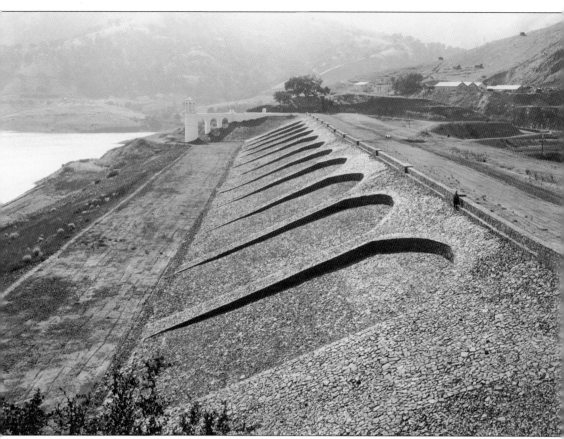

In 1925, the year that Moccasin Powerhouse came on line, Spring Valley Water Company was still the main supplier of potable water to the city. It built the earth-filled Calaveras Dam on Alameda Creek in the East Bay watershed near Sunol. Calaveras Dam would become a vital part of the future system for water storage and as a balancing reservoir. The original adit tower is barely visible in the distance. (Photograph by Horace Chaffee, August 30, 1926.)

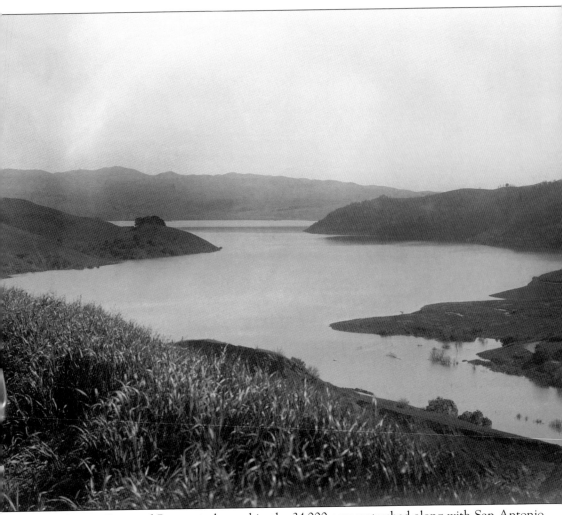

Calaveras Dam and Reservoir, located in the 34,000-acre watershed along with San Antonio Reservoir in Alameda County, is owned by the City and County of San Francisco. Construction of the new Calaveras Dam and Reservoir is underway downstream as part of the capital campaign after many years of in-depth studies and public process. The agency has assigned watershed keepers to work in the Tuolumne River watershed as well as in the Alameda and Peninsula watersheds. They protect and maintain the healthy status of these areas in accordance with the SFPUC watershed management plans. (Photograph by Horace Chaffee, April 5, 1927.)

Five

FOOTHILL TUNNEL TO SAN FRANCISCO BAY

The Hetch Hetchy aqueduct from Moccasin, westward to the terminus at Pulgas Water Temple, was constructed entirely in an enclosed conduit of tunnels and pipelines. The project headquarters in Groveland were moved downstream to Hetch Hetchy Junction Camp. The Foothill Tunnel was dug and blasted through bedrock during three years, from 1926 to 1929, and set new tunneling records. It stretches from Moccasin Reservoir to Oakdale, where it connects with three San Joaquin Pipelines that shunt water under pressure for an amazing 47.5-mile journey across the valley to the Coast Range Tunnel.

The construction of the Coast Range Tunnel was the most dramatic facet of the Hetch Hetchy construction. First, there was a tragic explosion in 1931 from the ignition of methane gas at Mitchell Shaft in the Coast Range Tunnel, which took 12 lives. Work was halted while an investigation took place that found no wrongdoing by the city. Michael O'Shaughnessy, who had managed funds with great scrutiny, was being openly criticized for cost overruns and project delays. Critics argued the pipeline should be built over the Coast Range Mountains instead of tunneling through, in order to expedite the completion. O'Shaughnessy and his supporters prevailed and kept the original engineering plan to use gravity-fed engineering via the tunnel.

A $6.5-million bond was finally issued in 1932, after a two-year delay (possibly the Wall Street Crash of 1929 had played a part), to complete the Coast Range Tunnel. San Francisco adopted a new city charter, creating an opportunity for critics to remove Michael O'Shaughnessy as chief engineer for the Hetch Hetchy Project. O'Shaughnessy had refused to cater to politicians who wanted their friends and relatives hired for the project or to the media that attempted to monopolize his precious time. He no longer had Mayor Rolph to keep critics at bay. In 1932, two years before completion of the aqueduct under a new city charter, Edward Cahill became the first general manager of utilities, and Lloyd McAfee, who had served under O'Shaughnessy, was appointed manager and chief engineer of the Hetch Hetchy Project.

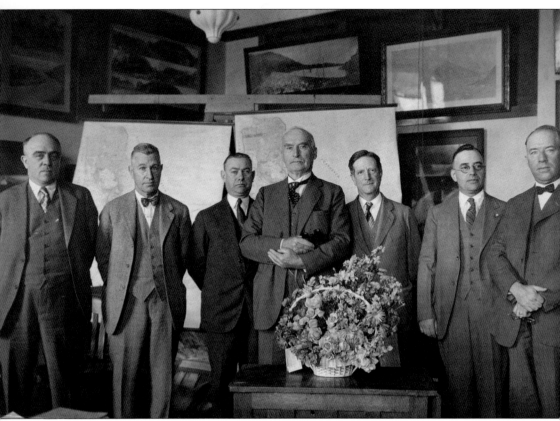

Despite some mounting public criticism of cost overruns and construction delays, Michael O'Shaughnessy maintained his resolve and commitment to the project. The staff of San Francisco's Bureau of Engineering, pictured here from left to right, includes Joe Callaghan, Max Bartell, Clyde Healy, Michael O'Shaughnessy, Nelson Eckart, Henry Ohmer, and Paul Ost. A $41-million bond was approved in 1928 to purchase Spring Valley Water Company, which would provide the additional 15 percent of potable water from the East Bay and peninsula watersheds, conveyed by the Hetch Hetchy system. That same year, one of the biggest engineering catastrophes in the country occurred. The St. Francis Dam in Southern California on the Los Angeles Aqueduct collapsed, and more than 600 people died. This tragedy ended the career of chief engineer William Mulholland, a self-taught engineer. (Photograph by Horace Chaffee, October 20, 1928.)

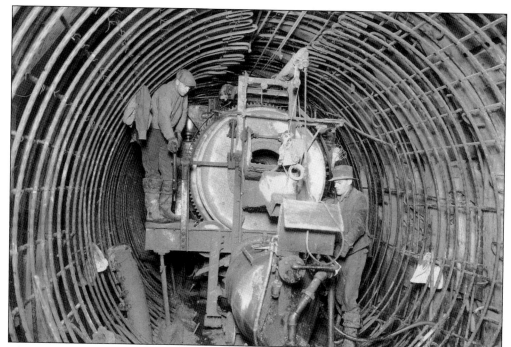

The Foothill Tunnel construction began in 1926 at Pedro Adit, pictured here. The tunnel stretched for 15.8 miles to Oakdale, where it connects with the San Joaquin Pipelines. (Photograph by Horace Chaffee, March 21, 1929.)

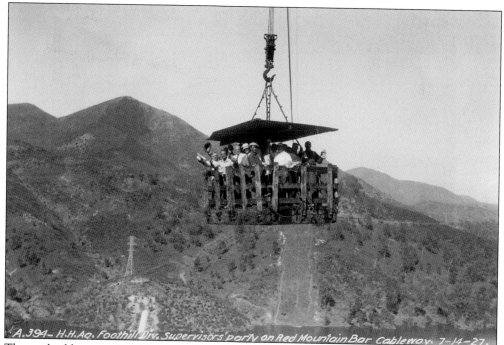

The steel cableway at Red Mountain Bar transports a group of supervisors working on the Foothill Tunnel up and over the Tuolumne River. The cableway had a capacity of five tons. (Photograph by Horace Chaffee, July 14, 1927.)

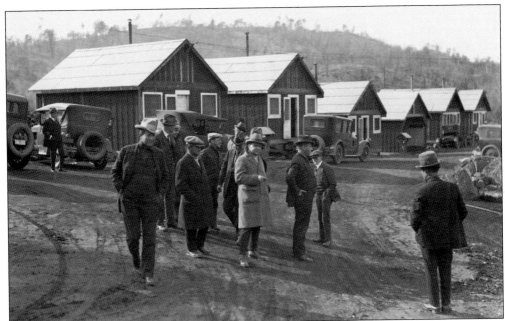

Construction of Foothill Tunnel lasted three years and was initiated at 10 different work sites. There also were six different camps that now had appurtenances, such as water, power, telephone lines, and roads near the main offices. Hetch Hetchy city workers set new national records for their tunneling work and enjoyed healthy competition with outside contractors, who also did their part. (Photograph by Horace Chaffee, January 21, 1926.)

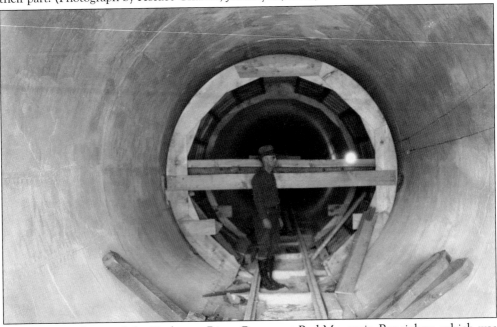

Foothill Tunnel crossed the Tuolumne River Canyon at Red Mountain Bar siphon, which was needed once the Don Pedro Lake was created by Modesto and Turlock Irrigation Districts. This worker is inside one of the 10 sites where construction was taking place at Red Mountain Bar West Portal at the Tuolumne River crossing. (Photograph by Horace Chaffee, March 21, 1929.)

Red Mountain Bar pipeline is approximately 10 feet in diameter, comprised of 770 feet of steel that was anchored on multiple concrete bases. (Photograph by Horace Chaffee, October 11, 1933.)

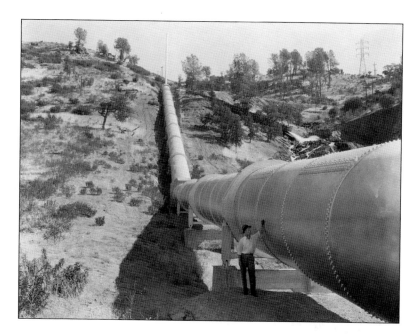

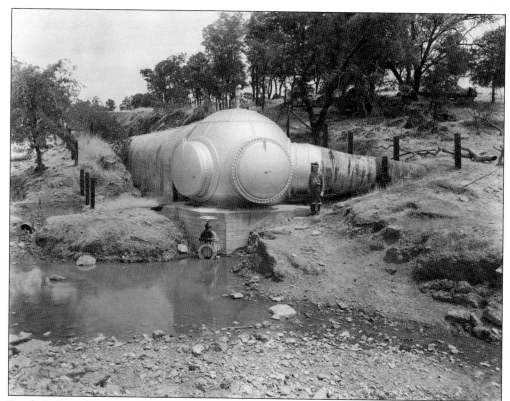

Foothill Tunnel was completed in 1929 and connected to Oakdale Portal. Here, water enters San Joaquin Pipelines Nos. 1, 2, and 3, constructed over a period of 37 years. (Photograph by Horace Chaffee, August 8, 1936.)

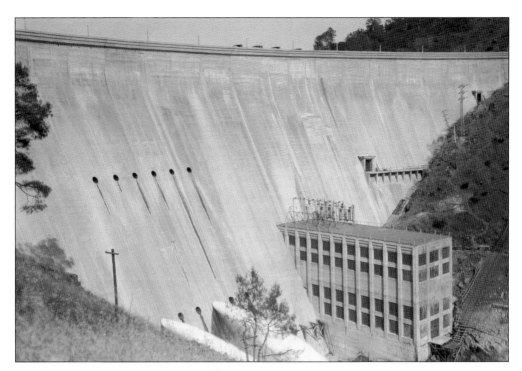

Modesto and Turlock Irrigation Districts built their original Don Pedro Dam, pictured above and below, at the same time O'Shaughnessy Dam was under construction in 1923. This dam is under Lake Don Pedro today. The New Don Pedro Dam, built in 1949, stands about 1.5 miles farther downstream and has a capacity to impound more than two million acre-feet of water in the reservoir from the Tuolumne River. In 2011, these irrigation districts diverted more than half of the water from the Tuolumne River. Recreation on the reservoir, including fishing and houseboat rentals, is under the management of the Don Pedro Recreation Agency. (Both photographs by Horace Chaffee, June 5, 1923.)

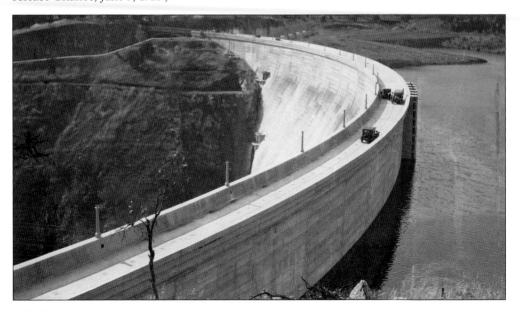

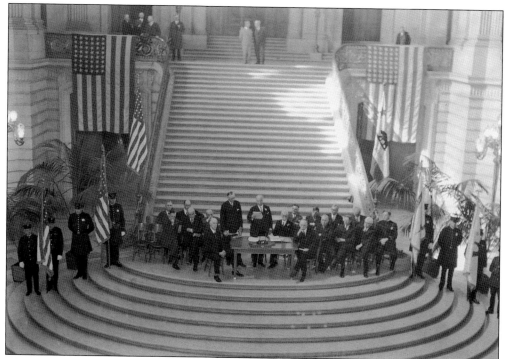

The Spring Valley Water Company was purchased by the City and County of San Francisco after 70 years of delivering water in the Bay Area. Company owners saw the inevitability that once the Hetch Hetchy system was operational they would be out of business. They sold the company to San Francisco for approximately $40 million in 1930. This ceremony was held to celebrate the transaction in San Francisco's City Hall Rotunda. (Photograph by Horace Chaffee, March 3, 1930.)

The San Joaquin Pipeline is one of three pipelines that cross the valley. Here, it "daylights" above surface over a slight depression. (Photograph by Horace Chaffee, August 8, 1936.)

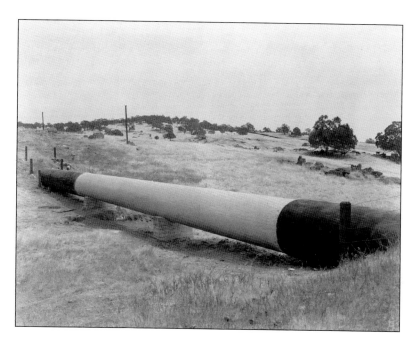

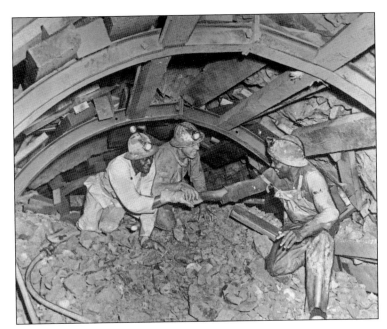

Tunnelers, or miners, give each other the congratulatory handshake to signify the "holing through" of a tunnel around 1934.

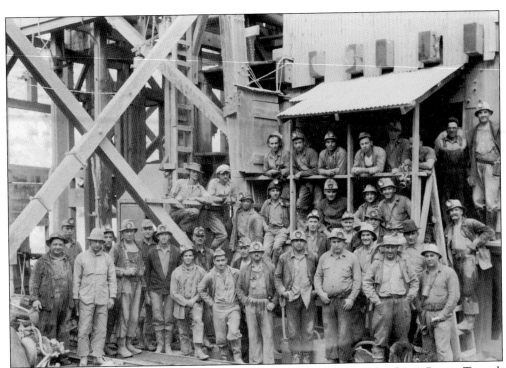

Methane gas was first detected in Mocho Shaft, one of four shafts in the Coast Range Tunnel, so stricter enforcement of safety measures took place on the project. The tunnel crew of 1934 is seen here. (Photograph by Horace Chaffee, January 3, 1934.)

The Mitchell Shaft tunnel crew poses at a crosscut in the Coast Range Tunnel. (Photograph by Horace Chaffee, February 4, 1930.)

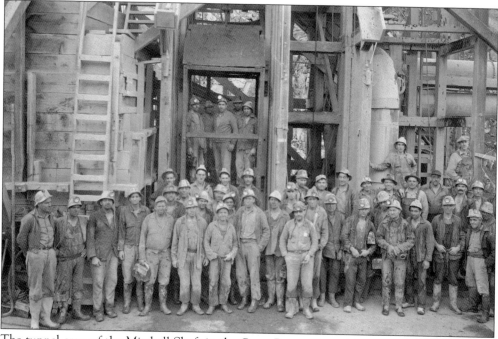

The tunnel crew of the Mitchell Shaft in the Coast Range Tunnel is pictured three years after the methane explosion, which took the lives of 12 workers in 1931. A thorough investigation was conducted, and it was determined that there had not been negligence on the part of the city. (Photograph by Horace Chaffee, January 4, 1934.)

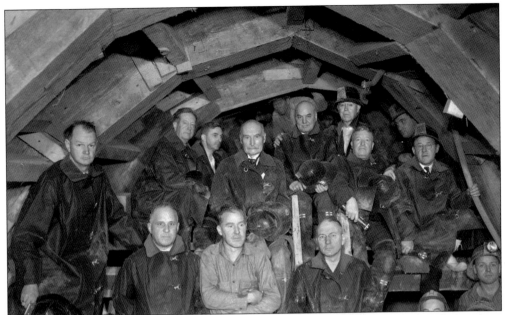

A celebration was held after the "holing through" between the Mitchell and Mocho Shafts, where workers met by tunneling from different directions in the Coast Range Tunnel. Mayor Rossi and Michael O'Shaughnessy attended the ceremonial handshake with head tunneler Pete Peterson, on the far left. O'Shaughnessy is pictured in the center with Mayor Rossi seated second from the right in the back row. (Photograph by Horace Chaffee, January 5, 1934.)

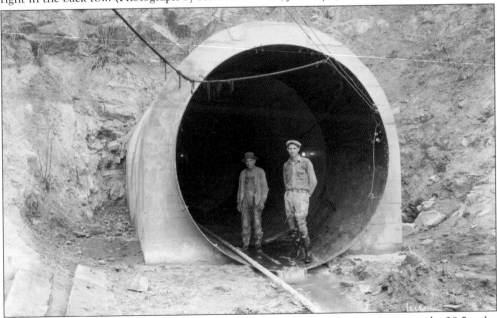

The final leg of the Hetch Hetchy aqueduct, before it would reach the Bay Area, was the 28.5-mile-long Coast Range Tunnel, excavated through the Coast Range Mountains in order to continue the use of gravity-fed water delivery. It connected to the Irvington Tunnel in Fremont, which at the time of construction was mostly comprised of farmland. (Photograph by Horace Chaffee, January 4, 1933.)

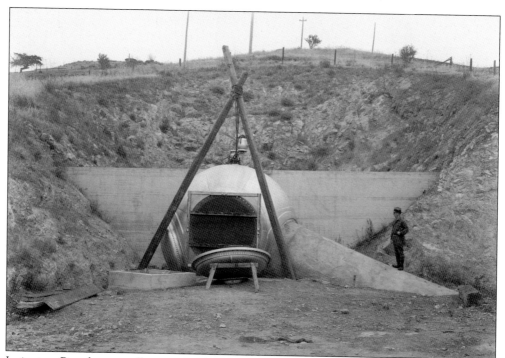

Irvington Portal eventually connected to four Bay Division Pipelines that carry water to the southern peninsula and to San Francisco. (Photograph by Horace Chaffee, May 3, 1934.)

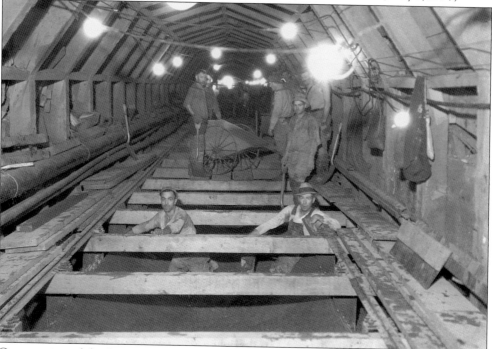

Construction of the Irvington Tunnel portal in 1931 was in the East Bay. The new Irvington Tunnel is one of three under construction in the current capital campaign to provide seismic redundancy and opportunities for maintenance shutdowns.

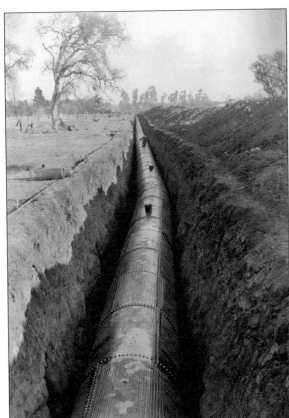

The Irvington Tunnel connects to four separate Bay Division Pipelines and travels west to the Bay Area. The Bay Division Pipelines (BDPL) Nos. 1, 2, 3, and 4 have diameters of 60, 66, 78, and 96 inches, respectively. All four pipelines cross the Hayward and San Andreas Faults. BDPL Nos. 1 and 2 cross San Francisco Bay to the south of the Dumbarton Bridge; BDPL Nos. 3 and 4 run to the south of the bay to San Jose. BDPL No. 1 was constructed through Redwood City at the same time that O'Shaughnessy Dam was being built. The construction of a fifth BDPL under the bay by the SFPUC is a vital part of the current capital campaign. (Photograph by Horace Chaffee, December 27, 1923.)

Workers rolled and shaped metal plates to produce pipeline for the BDPL No. 1 that crossed the bay to the peninsula in 1924. (Photograph by Horace Chaffee, January 16, 1924.)

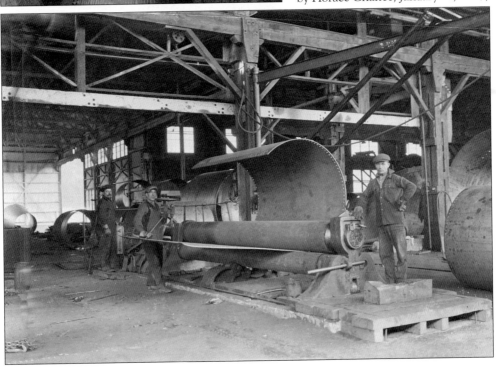

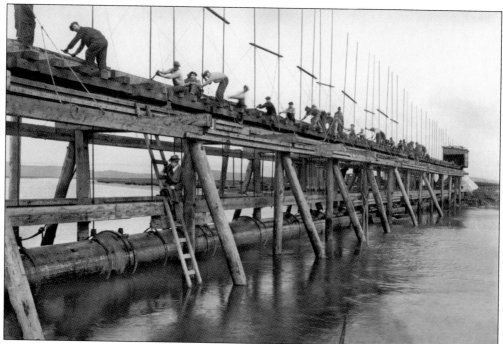

This portion of the BDPL No. 1 is 42 inches in diameter. Here, workers are ratcheting the pipeline downward in order to lower and place it underwater across the Newark Slough in San Francisco Bay. (Photograph by Horace Chaffee, February, 14, 1925.)

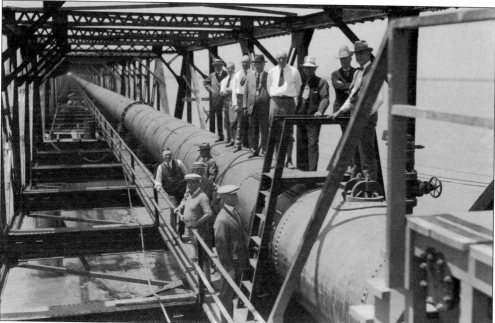

The BDPL No. 1 was constructed across the bay near the Dumbarton Bridge on a steel trestle and bridge with a caisson, under which bay pipes connect with those on the bridge. This photograph shows a caisson to the west along BDPL No. 1, which went into full service in 1926. (Photograph by Horace Chaffee, June 4, 1926.)

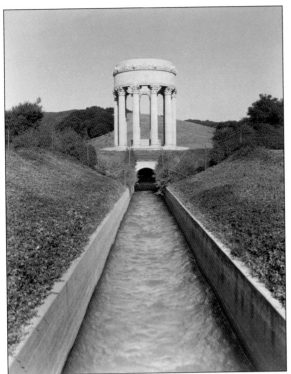

The Pulgas Water Temple channel is full of water flowing into the Crystal Springs Reservoir. The Beaux Arts–style temple with its tall, fluted columns adorned with ornate Corinthian capitals, resembles the architecture of ancient Roman water temples. William Merchant, a student of architect Bernard Maybeck, designed it. Master stone carver Albert Bernasconi created the temple based on Merchant's design; today, it overlooks a large reflecting pool.

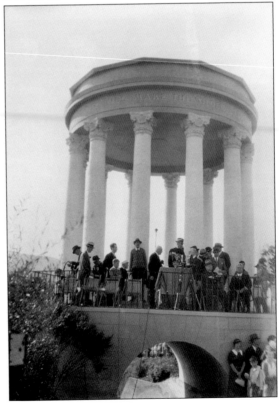

The celebration of the completion of the Hetch Hetchy aqueduct in 1932 at the Pulgas Water Temple was a huge event that was broadcast on national radio. Secretary of the Interior Harold Ickes, San Francisco mayor Angelo Rossi, and supervisor Jesse Coleman spoke to a large gathering and praised the leadership of engineer Michael O'Shaughnessy. O'Shaughnessy was not present, though. He had suffered a fatal heart attack in his home in San Francisco, just 12 days prior to the dedication. (Photograph by Horace Chaffee, October 28, 1934.)

Six

CONSTRUCTION AFTER THE AQUEDUCT

Even though the 160-mile-long Hetch Hetchy Aqueduct was completed with its terminus at Crystal Springs Reservoir, there was more construction needed to upgrade and complete other portions of the system. Large building projects included the addition of the BDPL Nos. 3 and 4 and San Joaquin Pipelines Nos. 2 and 3. Phase two of the O'Shaughnessy Dam was completed in 1938 when the dam was raised another 85.5 feet to its present capacity of 360,360 acre-feet of water.

One of the biggest undertakings next for the SFPUC was the development of the Cherry Valley Project in order to meet future obligations for water releases to the Modesto and Turlock Irrigation Districts. The Raker Act of 1913 had authorized a third impounding reservoir in the High Sierra, and the demand for water was increasing with the development of agricultural lands in the San Joaquin and Central Valleys. The Cherry Valley Project, located in Stanislaus National Forest, would allow the city to improve water reliability for its customers and increase its hydropower generation substantially. The SFPUC built Cherry Valley Dam in six years on Cherry Creek in Stanislaus National Forest. This enabled the city to build the third and largest powerhouse, called Holm Powerhouse, which was completed in 1960. The city also constructed the Canyon Power Tunnel, which transports water from Hetch Hetchy Reservoir to the Kirkwood Powerhouse, built in 1967.

In 1949, a cooperative agreement was reached with the City and County of San Francisco and the Army Corps of Engineers that enabled Modesto and Turlock Irrigation Districts to build a massive new Don Pedro Dam. Construction began in 1967, downstream from the original Don Pedro Dam. The SFPUC invested $45 million of voter-approved bonds to partially fund the construction of the dam and the new reservoir. The federal government also funded $5.4 million of the project for flood control.

The San Francisco Civic Center streetlights and city hall are powered by renewable energy from the Hetch Hetchy Project. Hydropower is one of the most sustainable benefits of the system that produces 1.7 billion kilowatt hours of electricity, or enough to power 200,000 homes each year. This electricity provides approximately 20 percent of the overall energy needed for San Francisco municipal services, including the airport, public libraries, hospitals, transportation, city hall, and approximately half of the city's streetlights. (Photograph by George Fanning, September 2, 1936.)

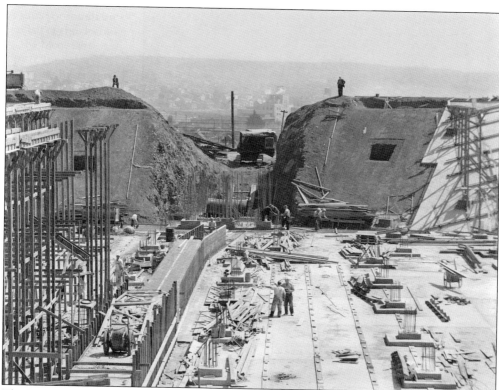

The University Mound Reservoir, one of 12 distributing reservoirs in San Francisco, is located in the Excelsior District on the south side of the city. Originally, it was constructed in 1885 and expanded in the 1930s, pictured here looking east from the middle of the new structure. It is the second-largest reservoir in San Francisco (Sunset Reservoir is the largest), with a capacity to impound more than 140 million gallons of water. (Photograph by George Fanning, August 24, 1937.)

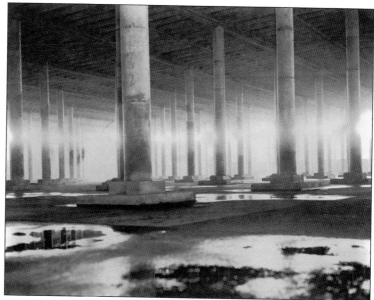

This is the interior of the University Mound Reservoir after completion and before filling with water. It was photographed on the day of a well-attended civic dedication. (Photograph by George Fanning, January 13, 1938.)

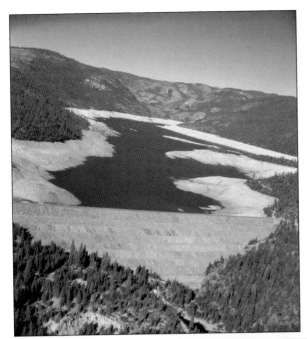

The Cherry Valley Dam and Reservoir, seen in this aerial photograph of the Sierra Nevada, was built between 1953 and 1955 as part of the Cherry Valley Project. The Cherry Valley Dam construction, in essence, created a second water delivery system that is overseen by the SFPUC. The project would meet the future water requirements for Modesto and Turlock Irrigation Districts. (Photograph by Carmen Magana, January 28, 1991.)

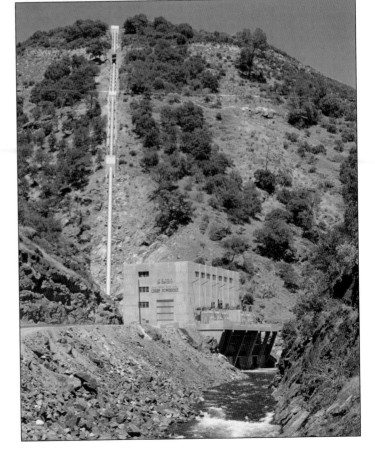

The Cherry Powerhouse pictured here was constructed and began operation in 1960 as part of the Cherry Valley Project. It was later renamed Holm Powerhouse and is the largest of three powerhouses operated by the SFPUC. Kirkwood Powerhouse was built near the Early Intake Powerhouse and was dedicated in 1967. (Photograph by Marshall Moxom, June 14, 1961.)

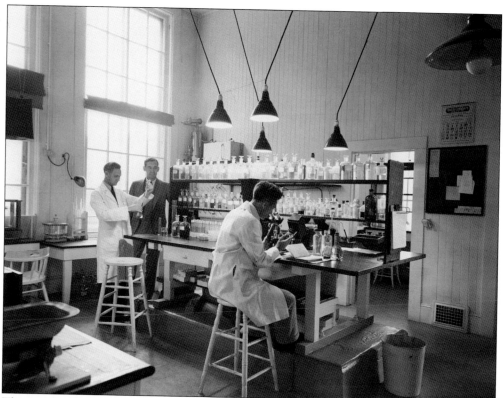

Thousands of water tests are performed at the SFPUC Water Quality Bureau every year by technicians and scientists along the entire Hetch Hetchy system. The SFPUC uses chloramines as a disinfectant and operates two water-treatment plants, one in the East Bay and one on the peninsula. The SFPUC also adds fluoride, which is required by local law to aid in the prevention of tooth decay. Pictured here is the interior of a SFPUC water-testing laboratory in 1940. (Photograph by George Fanning, September 9, 1940.)

Alameda Creek Siphon No. 2 was constructed in 1953 with a capacity to transport 134 million gallons of water between two portions of the tunnel. This siphon connects the two Coast Range Tunnel segments and transports water at Alameda Creek via an inverted, U-shaped pipeline. It moves water, when necessary, from the reservoir to the water treatment plant before putting it back in the aqueduct. (Photograph by George Fanning, August 25, 1953.)

Workers pour concrete for the construction of the Alameda Creek Siphon No. 2, which consisted of a pipeline that was a half mile long. (Photograph by George Fanning, August 31, 1953.)

Workers excavate the area for the east portal of the Alameda Creek Siphon No. 2, under construction for the new manifold foundation. (Photograph by George Fanning, October 2, 1953.)

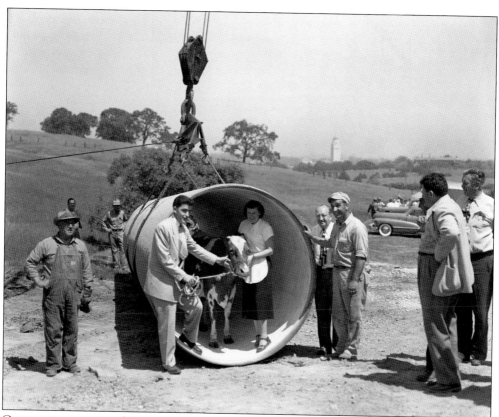

Construction continued for years on the four critical Bay Division Pipelines that transport water across the bay to millions of thirsty customers. This is a promotional shot for the construction of BDPL No. 3 in 1950. Today, the SFPUC is constructing a fifth BDPL across the bay, in case there is a major earthquake. It will allow older pipelines to be taken out of service for inspection and repair without disruption of water delivery. (Photograph by George Fanning, April 20, 1950.)

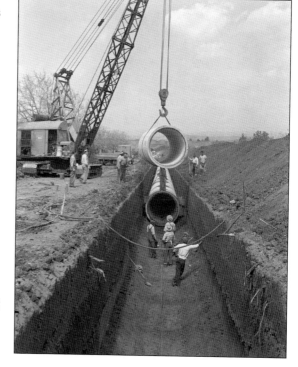

In this image facing northwest, SFPUC crews hoist and lower subterranean pipe for the BDPL No. 3. (Photograph by George Fanning, March 29, 1951.)

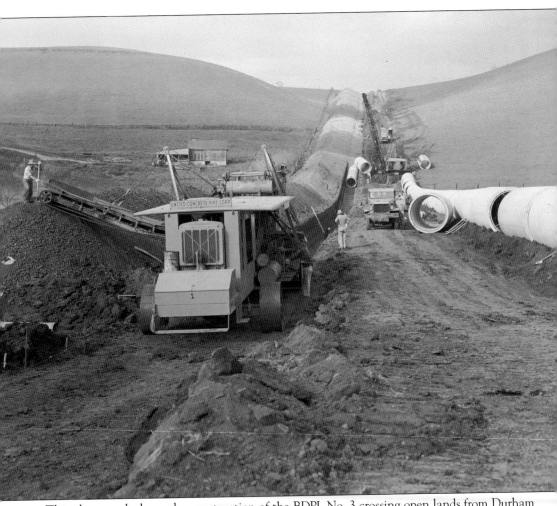

This photograph shows the construction of the BDPL No. 3 crossing open lands from Durham Road in what is now Fremont. (Photograph by George Fanning, January 8, 1951.)

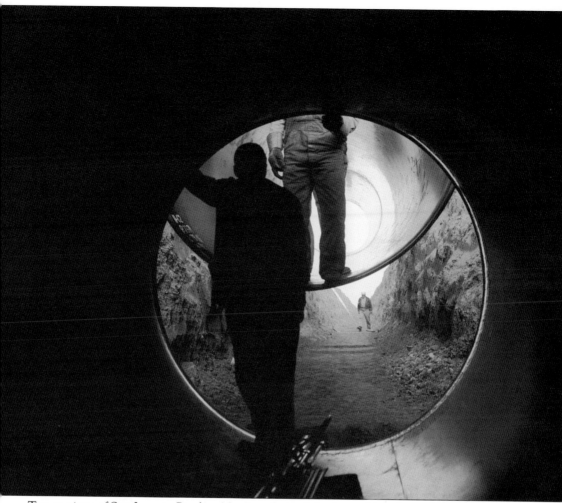

Two sections of San Joaquin Pipeline No. 3 are being joined near Vernalis in the Central Valley in this photograph showing two pipeline segments at once. (Photograph by Marshall Moxom, November 28, 1962.)

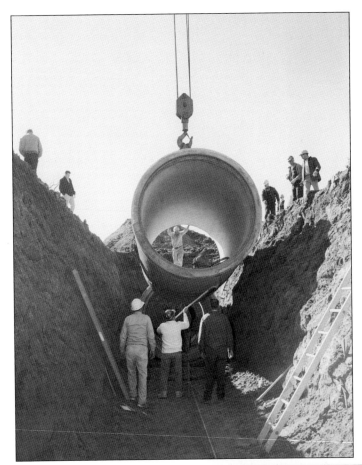

The first section of the 96-inch-diameter BDPL No. 4 is lowered into the trench. At the same time, the city had begun building the San Joaquin Pipeline No. 3. (Photograph by Ken Snodgrass, March 1, 1966.)

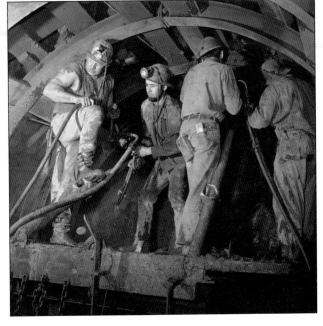

Tunnelers drilled at the entrance of the Crystal Springs Bypass Tunnel in the 1960s. A replacement tunnel was constructed in 2011. This pipeline allows water to be delivered directly to San Francisco, without first being stored in the Crystal Springs Reservoir. (Photograph by Ken Snodgrass, March 17, 1967.)

Seven

THE FUTURE OF SAN FRANCISCO WATER

In 2002, San Francisco voters approved Propositions A and E to fund, through revenue bonds, the new construction and rebuild of portions of the Hetch Hetchy system that were aging and were most vulnerable to earthquake damage. Increases in water rates over time will pay back the debt service on these bonds. This $4.6-billion public works capital campaign includes 35 local projects in San Francisco and 46 regional projects, three of which are new tunnels. Since the system traverses the Hayward, San Andreas, and Calaveras Faults, as well as many smaller ones, the focus of the Water System Improvement Program (WSIP) is on the infrastructure located in the Bay Area to increase seismic reliability. The program is scheduled for completion in July 2016. The people who rely on the pristine water source, including the wholesale customers outside of San Francisco, are shouldering their share of the costs to ensure water delivery for the future.

Seismic scientists at USGS predict another major earthquake will occur in the Bay Area that will be 7.0 or greater on the Richter magnitude scale within the next several decades. The SFPUC conducted in-depth reliability studies of its facilities, and it was determined that a major earthquake could cause catastrophic failure with no water delivery for 30 days or more. In order to prevent these possible outages in water delivery, the city has committed to strengthening the system with some very ambitious undertakings. Since the 1989 Loma Prieta and 1995 Kobe earthquakes, much has been learned in engineering about liquefaction that could undermine pipelines, tunnels, and other facilities.

In the last decade, the SFPUC has implemented numerous green, sustainable programs, including the installation of municipal solar projects, rain barrel catchment programs, water conservation programs, and retrofitting offices and streetlights with Light Emitting Diode (LED) efficient bulbs. The agency continues to explore other alternative energy sources such as wind and wave power. Once again, San Francisco is earning its proud moniker, "The City That Knows How," bestowed upon it by Pres. William Howard Taft when he visited San Francisco in 1911.

The Mount Davidson Pump Station and Tank upgrade project in San Francisco was completed in 2009 to replace aging infrastructure. The City Distribution Division of the SFPUC oversees the delivery of water within the 49-square-mile area of the city. This includes more than 1,191 miles of pipelines under city streets, with some dating back to 1857. There are 12 municipal impounding reservoirs, six water storage tanks, and seven pump stations in San Francisco. These facilities create different pressure districts to utilize gravity at varying elevations to deliver water within the city limits. (Photograph by Robin Scheswohl, December 11, 2008.)

A worker welds a steel crossover pipeline to replace a portion of the existing 90-inch BDPL No. 4 at Guadalupe River crossover in Santa Clara for seismic reliability. The crossover project includes the construction of subterranean vaults. These vaults contain new valves to control flows between BDPL Nos. 3 and 4 and new emergency backup generators. (Photograph by Robin Scheswohl, November 17, 2009.)

A section of steel tunnel is lowered into the new Crystal Springs Bypass Tunnel to replace the 80-year-old tunnel on the peninsula as part of the WSIP. (Photograph by Katherine Du Tiel, May 18, 2010.)

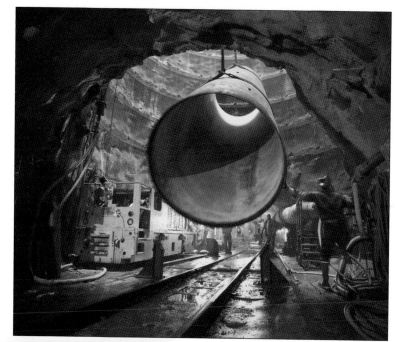

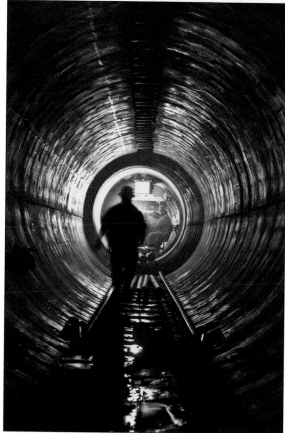

The new Crystal Springs Bypass Tunnel is 96 inches in diameter and 4,200 feet long. It conveys water directly to San Francisco, bypassing the reservoir on the peninsula. Here, a steel pipe is transported into the tunnel on a rail system. (Photograph by Katherine Du Tiel on May 18, 2010.)

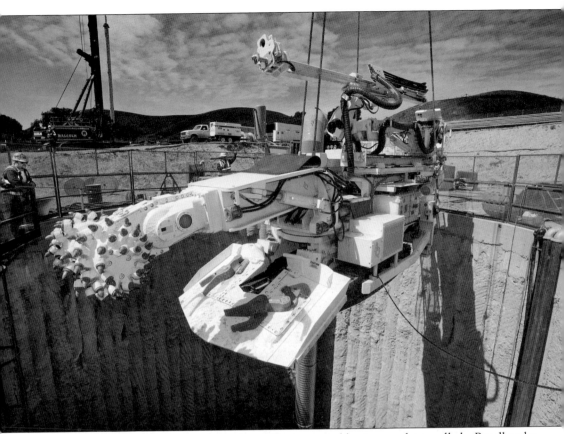

The New Irvington Tunnel construction utilizes a tunnel boring machine called a Roadheader, shown as it is lowered into the Vargas Shaft to begin boring. (Photograph by Robin Scheswohl, April 14, 2011.)

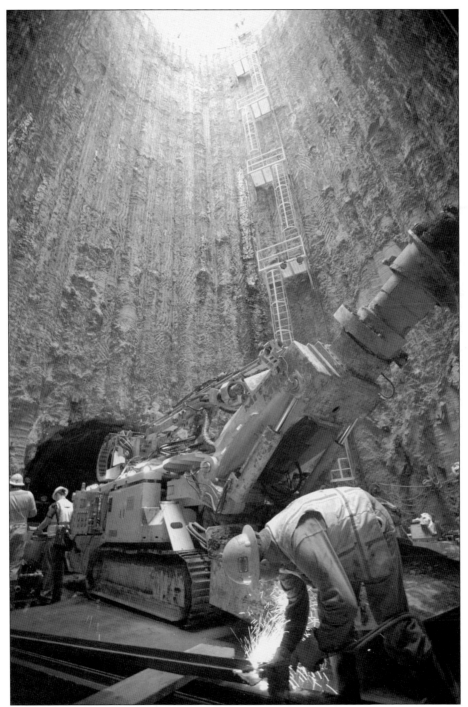

A Roadheader Tunnel Boring Machine (TBM), lowered into the Vargas Shaft, is the starting point for creating the New Irvington Tunnel in the East Bay. The tunnel is 3.5 miles long and 10.5 feet in diameter. It will stretch from Sunol Valley to Fremont and will lie parallel to the existing tunnel, allowing the agency to inspect the original pipeline for repairs for the first time since it was constructed in 1932. (Photograph by Katherine Du Tiel, May 25, 2011.)

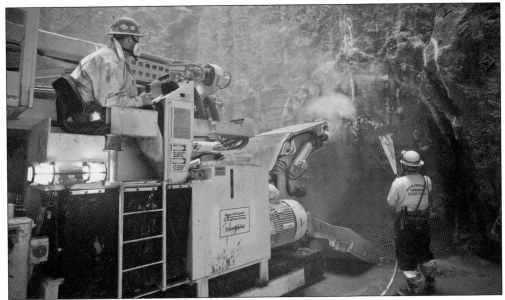

The New Irvington Tunnel Vargas Shaft in Sunol is 115 feet deep. This photograph shows a Roadheader boring machine in action. Crews began tunneling west toward Irvington Tunnel and then east to Alameda West Portal with the Roadheader TBM excavating inside the shaft. This shaft is one of four different faces, or directions, for excavating and tunneling of the New Irvington Tunnel. (Photograph by Katherine Du Tiel, May 25, 2011.)

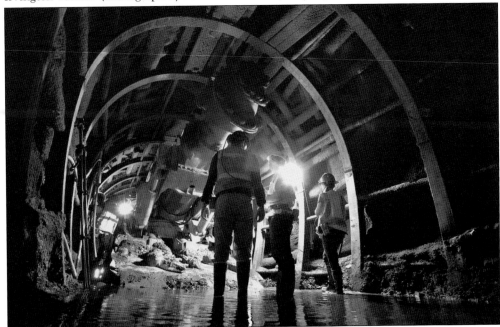

This view shows the Roadheader burrowing inside the New Irvington Tunnel construction site, Sunol. The TBM, sometimes called a mole, provides an alternative to blasting and drilling during tunnel excavation. The benefits of using a TBM include the production of smoother tunnel walls that can cut the costs of having to line them. A TBM also minimizes the disturbance to the surrounding grounds. (Photograph by Robin Scheswohl, June 19, 2011.)

A photograph of the interior of the New Irvington Tunnel shows the electrical and ventilation lines running along the sides of the tunnel. The tunnel is approximately 12 feet high, 14 feet wide, and 18,300 feet long. As part of this project, additional security improvements will be made. (Photograph by Robin Scheswohl, June 19, 2011.)

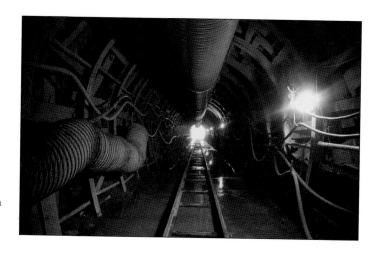

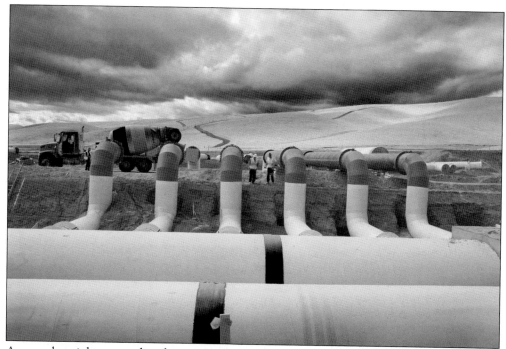

A new ultraviolet water disinfection treatment plant at Tesla Treatment Facilities was one of the first projects completed for the SFPUC capital campaign. It was built to provide added water quality protection, with the installation of 12 ultraviolet units that rid the water of unwanted microorganisms, including cryptosporidium. Pictured here are the new, 48-inch-diameter elbow pipelines at the new facility that help regulate the flow and pressure of the water. (Photograph by Katherine Du Tiel, August 6, 2009.)

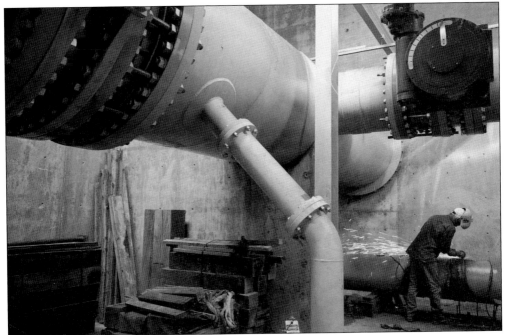

An arc welder works to ensure seismic reliability on the aging San Joaquin Pipeline at the Pelican crossovers. This will provide water managers with more flexibility to move water between the three San Joaquin Pipelines in the case of a catastrophic event or during routine inspections. (Photograph by Robin Scheswohl, September 30, 2011.)

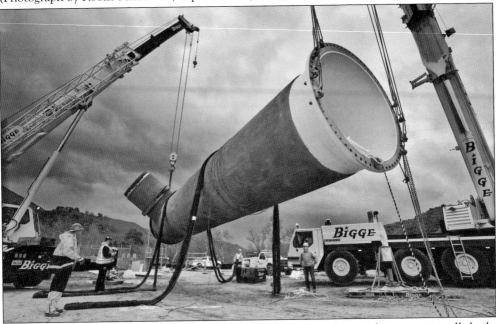

While modern equipment makes construction easier than when the aqueduct was originally built, it is still very precarious. Here, an 84-inch-diameter steel standpipe illustrates just one of the many hazards as it is hoisted into position. It will become the Alameda Siphon No. 4 in Sunol, east of Alameda Creek. (Photograph by Robin Scheswohl, March 18, 2011.)

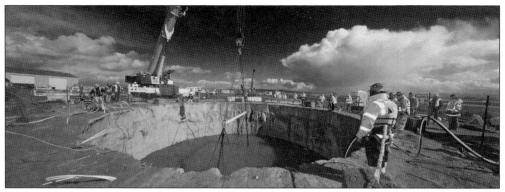

Workers lower rebar into the Ravenswood Shaft to build the BDPL No. 5, also referred to as the Bay Tunnel Project. This new five-mile-long tunnel with a nine-foot diameter will travel under San Francisco Bay. (Photograph by Robin Scheswohl, February 17, 2011.)

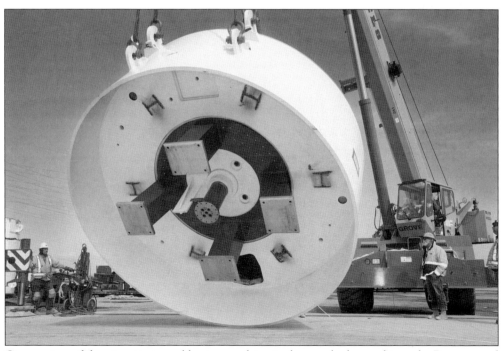

One portion of the gigantic tunnel boring machine is about to be lowered into the Ravenswood Shaft for excavation of the BDPL No. 5. (Photograph by Robin Scheswohl, May 23, 2011.)

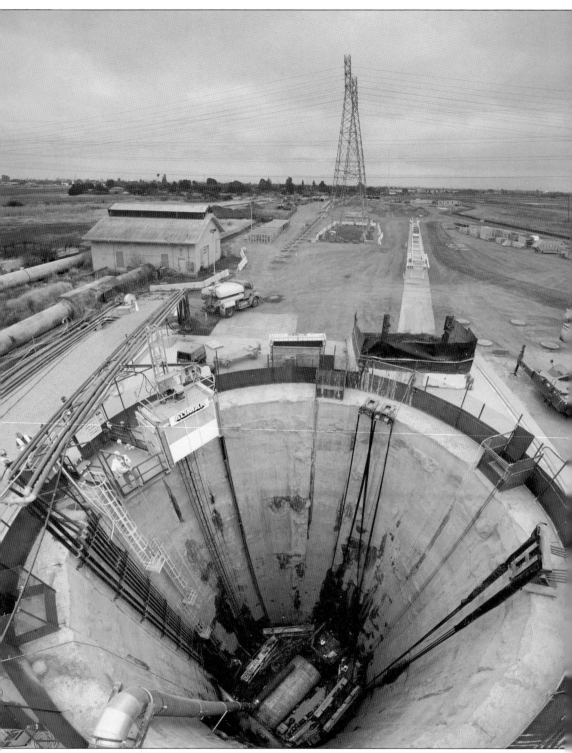

This photograph gives a bird's-eye view of the Ravenswood Shaft of the Bay Tunnel Project. (Photograph by Robin Scheswohl, August 27, 2011.)

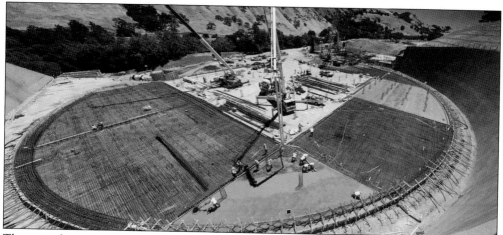

The capital campaign includes a project to upgrade the Sunol Valley Water Treatment Plant, increasing storage capacity so the agency can provide water to meet basic customer demands during a catastrophic event. A new, circular treated-water reservoir was built to hold an additional 17.5 million gallons of water in Sunol. (Photograph by Robin Scheswohl, July 21, 2011.)

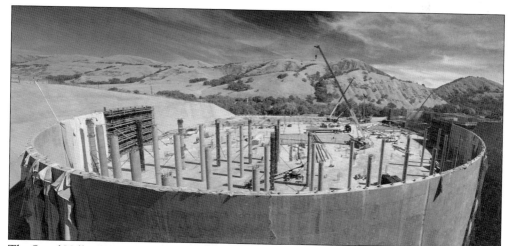

The Sunol Valley Water Treatment Plant, pictured here, which treats water from the San Antonio and Calaveras Reservoirs, is one of two water treatment plants operated by the SFPUC. The other facility is Harry W. Tracy Water Treatment Plant, built in the 1970s, which is located on the peninsula and treats water from the Crystal Springs, San Andreas, and Pilarcitos Reservoirs. (Photograph by Katherine Du Tiel, September 29, 2011.)

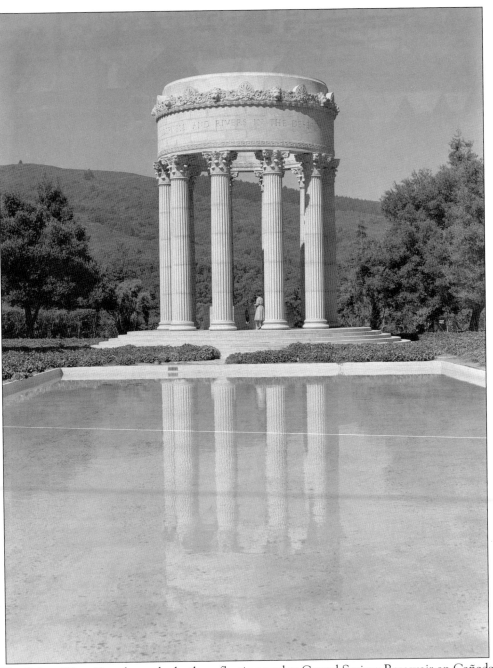

The Pulgas Water Temple overlooks the reflecting pool at Crystal Springs Reservoir on Cañada Road in San Mateo County. The peninsula watershed, south of San Francisco along Highway 280, comprises approximately 23,000 acres. It embodies Lower and Upper Crystal Springs, Pilarcitos, and San Andreas Reservoirs. Wildfires, which can lead to erosion, causing habitat destruction and degradation of water quality, are a major concern for water utility managers in a watershed. In 2003, the SFPUC opened a 10-mile-long stretch to the public called the Fifield-Cahill Ridge Trail. More information can be obtained at trail.sfwater.org. (Photograph by Marshall Moxom, May 10, 1959.)

BIBLIOGRAPHY

Freeman, John R. *The Hetch Hetchy Water Supply for San Francisco, 1912.* San Francisco: Rincon Publishing, 1912.

Hanson, Warren D. *San Francisco Water and Power.* San Francisco: San Francisco Public Utilities Commission, 1985.

London, Jack. "The Story of An Eyewitness." *Collier's Weekly,* May 5, 1906.

Muir, John. "The Hetch-Hetchy Valley." *Sierra Club Bulletin,* vol. 6, 1908.

O'Shaughnessy, M.M. *Hetch Hetchy: Its Origin and History.* San Francisco: Recorder Printing and Publishing, 1934.

San Francisco Water and Power. San Francisco: San Francisco Public Utilities Commission, 1949, 1985, 1987, 2002, and 2005 editions.

Schussler, Hermann. *The Water Supply of San Francisco, California: Before, During, and After the Earthquake of April 18th, 1906, and the Subsequent Conflagration.* New York: Martin B. Brown Press, 1906.

The State of the Sierra. Truckee, CA: The Sierra Business Council in partnership with the Sierra Nevada Conservancy, 2007.

Water for a Sustainable City: Hetch Hetchy and San Francisco. San Francisco: American Institute of Architects, San Francisco in partnership with the San Francisco Public Utilities Commission, 2010.

Wurm, Ted. *Hetch Hetchy and Its Dam Railroad: The Story of the Uniquely Equipped Railroad that Serviced the Camps, Dams, Tunnels, and Penstocks of the 20-year Construction Project to Bring Water from the Sierra to San Francisco.* Berkeley, CA: Howell-North Books, 1973.

DISCOVER THOUSANDS OF LOCAL HISTORY BOOKS FEATURING MILLIONS OF VINTAGE IMAGES

Arcadia Publishing, the leading local history publisher in the United States, is committed to making history accessible and meaningful through publishing books that celebrate and preserve the heritage of America's people and places.

Find more books like this at
www.arcadiapublishing.com

Search for your hometown history, your old stomping grounds, and even your favorite sports team.

Consistent with our mission to preserve history on a local level, this book was printed in South Carolina on American-made paper and manufactured entirely in the United States. Products carrying the accredited Forest Stewardship Council (FSC) label are printed on 100 percent FSC-certified paper.

MADE IN THE USA